SUFFOLK'S DEFENDED SHORE

Coastal Fortifications from the Air

SUFFOLK'S DEFENDED SHORE

Coastal Fortifications from the Air

Cain Hegarty and Sarah Newsome

ENGLISH HERITAGE

Suffolk
County Council

Published by English Heritage, Kemble Drive, Swindon SN2 2GZ
www.english-heritage.org.uk
English Heritage is the Government's statutory adviser on all aspects
of the historic environment.

© English Heritage 2007

Printing 10 9 8 7 6 5 4 3 2 1

Images (except as otherwise shown) © English Heritage or
© Crown copyright.NMR.

First published 2007

ISBN 978 1 873592 98 4

Product code 51173

British Library Cataloguing in Publication data
A CIP catalogue record for this book is available from the
British Library.

The National Monuments Record is the public archive of English
Heritage. For more information, contact NMR Enquiry and
Research Services, National Monuments Record Centre,
Kemble Drive, Swindon SN2 2GZ; telephone (01793) 414600.

Brought to publication by Joan Hodsdon,
Publishing, English Heritage.

Edited by John King
Indexed by Alan Rutter
Page layout by Simon Borrough

Printed in the United Arab Emirates by Oriental Press.

Front cover: Landguard Fort in 2005
(*NMR 23913/24 22-JUN-2005 © English Heritage.NMR*)

Back cover: The Bloodhound Mark II missile site at
RAF Bawdsey in 2005
(*NMR 23916/7 27-JUN-2005 © English Heritage.NMR*)

Contents

Acknowledgements

Numerous organisations and individuals generously contributed support, advice and material to the Suffolk Coastal National Mapping Programme project and the writing of this book. As this publication is about the application of aerial photography to archaeology, we would like to begin by thanking all those who kindly allowed the reproduction of their aerial photographs, including the National Monuments Record, the Imperial War Museum, the Ashmolean Museum, The National Trust, Ordnance Survey, The Hammond Collection, The Goldsworthy Collection, Pre-Construct Archaeology and Mrs Joanna Turner. Particular thanks go to Damian Grady for his excellent photographs of some challenging subjects.

Thanks also go to everyone who helped in our research and contributed to, or gave permission for, the reproduction of ground photography or illustrations. These include our colleagues at Suffolk County Council, the National Monuments Record, the Cambridge University Unit for Landscape Modelling (formerly CUCAP), the National Portrait Gallery, the Tank Museum, the Imperial War Museum, Douglas Atfield, Frank Gardiner, Adrian James, Louise K Wilson, Neil Wylie, John Smith, Peter White and Phil Hadwen, Geoff Dewing, Orwell Park School and Bettina Furnée. Additionally the phased plan of the earthworks at Orford Castle is based on the work of English Heritage's Archaeological Survey and Investigation team. Particular thanks are given to the families of Mr Dennis Huett and Mr Les Dinning.

As well as the research undertaken at the National Monuments Record, material at the National Archives and the Ipswich branch of the Suffolk Record Office was also consulted. Both organisations kindly gave permission for the reproduction of material in their care and helped us to use their archives effectively.

Wayne Cocroft, Jude Plouviez, John Schofield, Keith Wade and Helen Winton read drafts of the text and provided valuable comments which we have endeavoured to incorporate. Andrew Saunders read the final draft and we are grateful for his comments and hope that we have successfully tackled them in the final version of the text.

Finally we would like to thank all our colleagues who have supported us during our time working on the Suffolk Coast NMP project and this book, particularly members of English Heritage's Aerial Survey team whose individual contributions and support are too numerous to mention. Suffolk County Council's Archaeological Service also deserves a special mention, particularly the support and advice we have received from Tom Loader and Jude Plouviez over the past five years.

Cain Hegarty and Sarah Newsome
June 2006

Abbreviations

A&AEE Aeroplane and Armament Experimental Establishment
AA Anti-Aircraft
AFV Armoured Fighting Vehicle
ARP Air Raid Precautions
AVRE Armoured Vehicle Royal Engineers
AWRE Atomic Weapons Research Establishment
CASL Coastal Artillery Searchlight
CD Coastal Defence
CH Chain Home
CHEL Chain Home Extra Low
CHL Chain Home Low
CO Combined Operations
DoB Defence of Britain (project)
GCI Ground Controlled Interception
HAA Heavy Anti-aircraft Artillery
HER Historic Environment Record
LST Landing Ship Tanks
MoD Ministry of Defence
MPP Monuments Protection Programme
NATO North Atlantic Treaty Organisation
NMP National Mapping Programme
NMR National Monuments Record
OTH Over-The-Horizon (radar)
RAC Royal Armoured Corps
RAF Royal Air Force
RFC Royal Flying Corps
RNAS Royal Naval Air Service
ROC Royal Observer Corps
SMR Sites and Monuments Record
USAAF US Army Air Force

Note: Many of the aerial photographs used in this text show a detail of an enlargement from the referenced image. This and the date when the photograph was taken results in the image reproduction being of a variable quality.

North is to the top of a vertical aerial photograph unless indicated by the direction of the red arrow

1
The big picture

This book will tell the story of the military defence of the Suffolk coast over a period of about 2,000 years, from Britain's position on the western fringes of the Roman Empire to the global tensions of the Cold War. It will do this in a new way, being the first book to employ aerial photographs to give a fresh perspective on the development of a defensive landscape.

The book is based on information gathered from aerial photographs taken largely from the early 1940s to the present day. As part of English Heritage's National Mapping Programme (NMP), archaeologists working for Suffolk County Council and English Heritage examined thousands of aerial images of Suffolk's coast and estuaries with the aim of interpreting and mapping all the

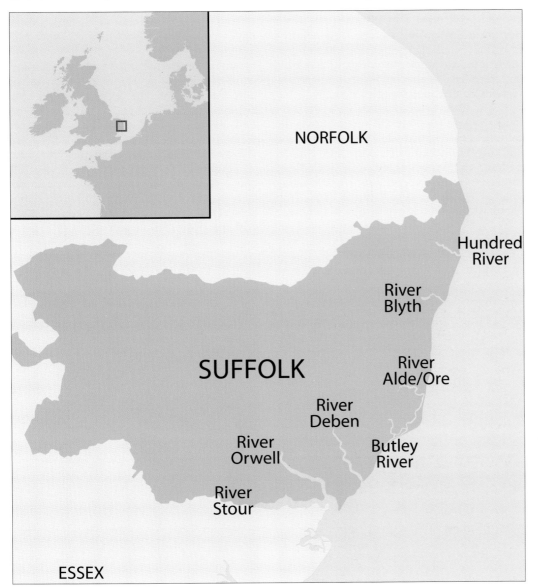

Fig 1.1 Aerial photographs were studied for 313 sq km of the Suffolk coast. The survey area was a 1km strip along the coast and a slightly wider area around all the major estuaries to allow a more rounded understanding of the relationship between the coast and its surroundings. The most easterly point in Britain is located on the Suffolk coast at Lowestoft, and Suffolk must have been an appealing destination for settlers, traders and raiders from the European mainland. (© Crown copyright. All rights reserved. English Heritage 100019088. 2007)

archaeological sites visible on the photographs (Fig 1.1). The project, covering 313 sq km, took place from 2001 to 2004.

Many of the sites visible on the photographs were part of Suffolk's 20th-century military coastal defences. These features can be seen on the photographs in incredible detail, located in some places alongside much older coastal defences. Modern defence strategies often incorporated their older neighbours into new defensive structures, to combat threats the older defences were never designed to face. The modern defences form only the most recent episode in the long story of military defence on Suffolk's coast.

In defence of the realm

The most easterly point of the British Isles lies on the Suffolk coast, looking across the North Sea towards mainland Europe. The county's low-lying, sparsely populated coastline is interrupted by numerous navigable estuaries, and must have seemed an inviting prospect to seaborne traders and invaders alike.

It is unsurprising, then, that military defences have been built at key points on the Suffolk coast since the first centralised authority came to Britain in the Roman period, to protect against a variety of threats. Germanic raiders, deteriorating relations with Europe during the 16th century, the Dutch navy, the Napoleonic wars and the airborne power of the Luftwaffe are just some of the threats that have prompted the construction of increasingly sophisticated and complex coastal defences.

Of course Suffolk's coast is not isolated. The county's coastal fortifications have usually been one part of Britain's wider coastal defences, reflecting both local fears and wider international tensions. Indeed, at times the varying nature of the invasion threats has meant that the Suffolk coast has taken a lesser role in national defence strategies and new defences have been concentrated elsewhere.

However, from the Roman shore fort at Felixstowe to the Atomic Weapons Research Establishment on Orfordness, the vulnerability of the Suffolk coast has meant that, more often than not, each era brought new defences.

The shifting shore

The dangers that prompted the construction of military defences on Suffolk's shore have now passed into history, but their archaeological remains still face numerous threats, both natural and man-made. Modern coastal developments such as the construction of the container port at Felixstowe, and changes in land use typified by the spread of arable agriculture onto coastal heathland, have led to the removal or destruction of historic remains.

Importantly, large parts of the Suffolk coast and estuaries are also environmentally sensitive areas. Maintaining a balance between the needs of wildlife conservation and the preservation and study of historic coastal military sites can be a challenging issue. For example, land management aimed at preserving important natural

Figs 1.2 and 1.3 Erosion has always had a dramatic effect on the Suffolk coast. Its destructive effect on the Slaughden Martello Tower, near Aldeburgh, can be seen on these aerial photographs taken in 1941 (below, left) and 2000 (below, right). Second World War anti-invasion defences are visible in front of the tower in the 1941 photograph. (MSO/31038/PO-6923 07-JUL-1941 English Heritage (NMR) RAF Photography; NMR 23496/15 23-APR-2004 © English Heritage.NMR)

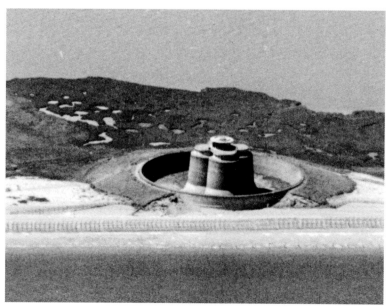

habitats can make access to often already remote historic military sites difficult.

The greatest threat to historic coastal military defences, however, still comes from the sea. Geologically soft, the Suffolk coastline is greatly affected by coastal erosion. The sea has shaped the fortunes of those who live and work on the coast for centuries. Erosion has already destroyed many historic coastal sites and will inevitably claim more in the future (Figs 1.2 and 1.3). It is therefore important that we do our best to understand how the surviving sites form a vital part of Suffolk's coastal heritage.

There is growing recognition that our coastal heritage includes recent military remains which also need to be studied and, where possible, conserved. Aerial photographs are a valuable tool for this study, allowing the archaeologist to quickly survey large areas of coastal terrain which is often difficult to reach on foot.

Aerial photographs also offer an historic dimension not available to other survey methods. By examining aerial photographs dating from the 1940s onwards, archaeologists can discover how surviving modern defences originally fitted into wider defensive strategies and systems. Importantly, the photographs can also tell us a great deal about how the coast is changing and, in doing so, can show us what has already been lost to the sea.

Coastal fortifications from the air

It is in improving our understanding of the coast's recent military past that aerial photographs have proved particularly valuable, and this aspect of the survey results will be discussed in detail in the following chapters. Each chapter will illustrate the archaeological evidence for coastal defences from a period of Suffolk's history. Particular types of defence and significant individual sites will be discussed in case studies, illustrated by the superb aerial photographs that are available for this, one of the most important defensive landscapes in Britain.

The next chapter begins by describing the advantages of using aerial photographs for archaeological survey, and noting how the growth of aerial photography for archaeological research has always been closely associated with the development of military aerial reconnaissance technology.

(© Suffolk County Council)

Aerial photographs and surveys

Aerial photographs allow archaeologists to see into places that would be very difficult to reach on the ground, such as the restricted and environmentally sensitive nature reserve at Orfordness, and wide, treacherous estuary mudflats like those of Holbrook Bay, shown above.

Surveys using aerial photographs work well alongside other archaeological and documentary survey techniques. For example, the National Mapping Programme (NMP) survey was conducted in conjunction with a rapid field survey of the coast undertaken by Suffolk County Council archaeologists. The rapid field survey identified many sites which were visible on the ground but not from the air, while the NMP survey identified many sites visible on aerial photographs but which were found to be either inaccessible or no longer visible on the ground. Most of Suffolk's surviving 20th-century wartime defences, and some of those now lost, have been recorded as part of the Council for British Archaeology's Defence of Britain (DoB) project. However the DoB project, a countrywide survey using volunteers, did not examine their original extent. A combination of approaches, such as ground surveys and those based on aerial photographs, can build up a more complete picture of our historic landscape than any single technique.

2
An aerial perspective

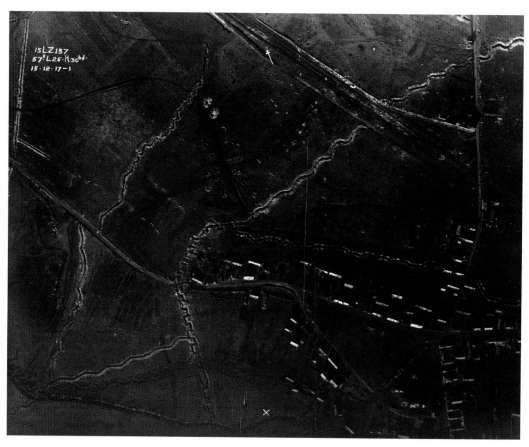

Fig 2.1 A reconnaissance photograph of First World War German trenches around the village of Ribecourt, near Cambrai in France, on the Western Front. Aerial reconnaissance and photographic interpretation were of vital importance in both World Wars. (IWM WWI AP Print No Box 740 15KZ 137 15-NOV-1917. Photograph courtesy of the Imperial War Museum, London)

The beginnings of aerial archaeology

The earliest known aerial photographs of a British archaeological site are thought to be those of Stonehenge, taken in 1906 from a tethered balloon. Since those photographs were taken innovations in camera and aeroplane technology have dictated the pace at which archaeological research using aerial photographs has developed. The beginnings of archaeological aerial reconnaissance lie in developments made during the First World War, when aerial photographs were used to locate and map German positions on the Western Front (Fig 2.1). Experiences gained during this period appear to have inspired many early pioneers of aerial archaeology, including the French Jesuit priest Antoine Poidebard, who photographed and mapped the Roman frontier system in Syria.

Advances in photographic and aviation technology continued in the inter-war years. In Britain several individuals began carrying out pioneering archaeological work using survey skills gained during the First World War. Most notable of these was OGS Crawford (Fig 2.2), who applied experience gained as an Observer in the Royal Flying Corps to photographing and mapping archaeological sites, particularly in Wiltshire, Hampshire and Dorset. His work led to many important discoveries, including the 'lost' stretch of the Stonehenge Avenue (Figs 2.4 and 2.5).

Crawford is now regarded by some as the father of British aerial archaeology. Others

Fig 2.2 OGS Crawford – pictured here in 1938, after an extended journey around Europe and North Africa – was appointed the Ordnance Survey's first Archaeology Officer in 1920. His volume Wessex from the Air, *produced with Alexander Keiller, was ground-breaking in its use of aerial photographs combined with interpretative maps to describe archaeological sites. (English Heritage.NMR)*

working in this field included Squadron Leader Gilbert Insall who, after being awarded the Victoria Cross in the First World War, also made a number of important discoveries from the air, including the site of Woodhenge in Wiltshire; and WGW Allen, an enthusiast with his own aircraft who spent much of his time photographing sites in the Thames Valley.

The Second World War led to a hiatus in the development of aerial photography for archaeology, but the conflict did stimulate developments in aviation technology, along with rapid advancements in cameras and photographic interpretation techniques for military reconnaissance purposes. A number of famous archaeologists, including Stuart Piggott and Glyn Daniel, worked as aerial photographers or interpreters for wartime photo-reconnaissance units, and notable aerial archaeologists such as Derrick Riley, JKS St Joseph (Fig 2.3) and John Bradford drew on wartime experiences in their later archaeological careers.

A military legacy

The legacy of Second World War aerial reconnaissance included not only a generation of archaeologists who recognised the potential of aerial photography, but millions of photographs taken over much of Western Europe and beyond during and after the war. The vast majority of Second World War aerial photographs of continental Europe are now housed in The Aerial Reconnaissance Archives (TARA) at the University of Keele.

Fig 2.3 JKS St Joseph had a major influence on the development of aerial archaeology in Britain after serving in the RAF's Coastal Command during the Second World War. He made numerous stunning discoveries, particularly relating to the archaeology of Roman Britain, and founded the Cambridge University Collection of Aerial Photographs, the basis of which is his own photographs. (The photographic copy of the original print is held with the Cambridge University Collection of Air Photographs)

Fig 2.4 The Stonehenge Avenue, 1921. Photograph taken by the School of Army Cooperation. The continuation of the Stonehenge Avenue as a cropmark (see Fig 2.11) was discovered in 1923 by OGS Crawford whilst he was looking through negatives of photographs taken by the military. Prior to Crawford's discovery only the upstanding earthwork section of the Avenue was known. Crawford proved the existence of the ditches in subsequent excavations. (NMR CCC/8544/75 15-JUN-1921 English Heritage (NMR) Crawford Collection)

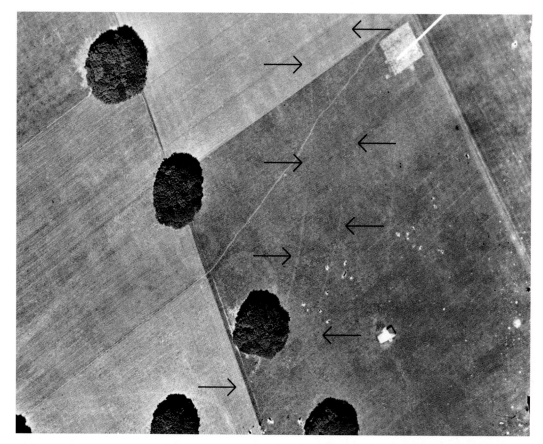

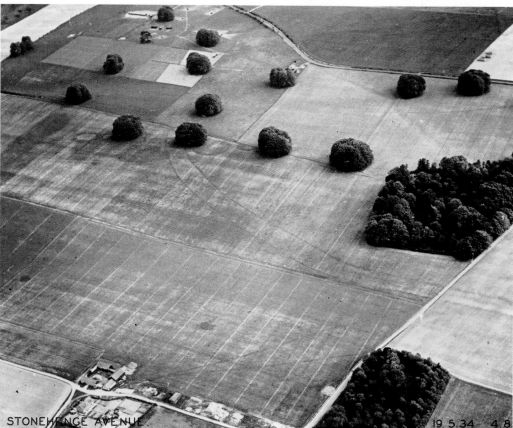

Fig 2.5 The Stonehenge Avenue, 1933. Photograph taken by WGW Allen. (AN1167-Allen, Ashmolean Museum, Oxford)

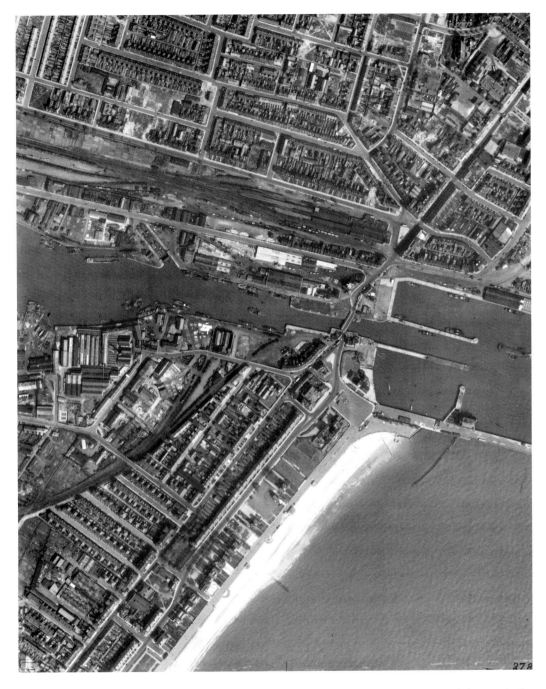

Fig 2.6 A typical 1940s RAF vertical photograph, showing the harbour area at Lowestoft in May 1947. The National Monuments Record in Swindon holds RAF photographs taken in England during and after the Second World War. (RAF CPE/UK2063 6027 14-MAY-1947 English Heritage (NMR) RAF Photography)

The Royal Air Force (RAF) photographed Britain during and after the war, in part to assess home defences and train air crew and interpreters. Immediately after the war the RAF undertook blanket coverage of the country for the National Survey, commissioned by the Ordnance Survey to aid town planning and reconstruction (Fig 2.6). The RAF photographs of England, along with some taken by the US Army Air Force, are housed at English Heritage's archive, the National Monuments Record (NMR), in Swindon.

The photographs are mainly verticals, although a collection of oblique RAF photographs also exists. Vertical photographs show a plan view, while oblique ones show a perspective view. Vertical photographs are taken in a specific way so that they can be combined to produce three-dimensional images, making them particularly useful for mapping purposes (Fig 2.7).

Today the NMR's RAF photographs are an extremely valuable resource, providing a unique record of England in the 1940s and 1950s. They are particularly useful for

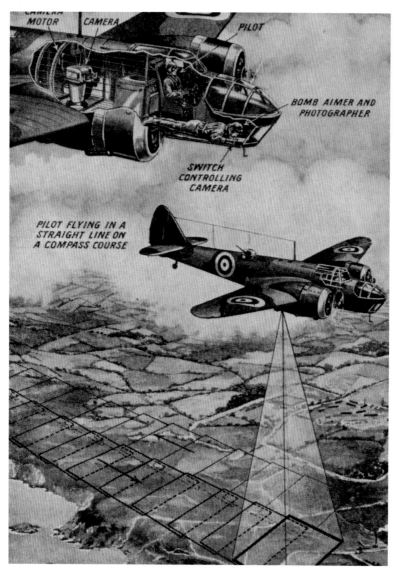

Fig 2.7 Vertical photographs are taken by an aeroplane flying in a straight line, at a fixed height and speed. A specially calibrated camera takes photographs at a set interval so that each frame overlaps with the previous one by about 60 per cent, so that any ground feature will be present in at least two frames. This overlap means that pairs of consecutive photographs can be viewed using a stereoscope to produce a three-dimensional ('stereo') image. (Hawkes, E 1942, Britain's Wonderful Fighting Forces, 115. London: Odhams Press) (© IPC+ Syndication)

Fig 2.8 The remains of a Second World War concrete pillbox in the hamlet of Shingle Street. A programme of post-war demolition and the revages of erosion mean that such remains which survive on the county's coast today represent only a small fraction of those visible on wartime aerial photographs. (© Suffolk County Council)

studying the country's Second World War defences and other military installations, especially coastal ones, many of which have since been destroyed by erosion or dismantled (Fig 2.8). The photographs not only record moments in time (Fig 2.9) but improve our understanding of the wartime landscape, providing true ground plans for comparison with documentary evidence, and allowing us to fill in gaps between the isolated structures that survive today. In some areas a sequence of photographs over a short period of time can reveal the changing nature of defence installations. Finally, and just as importantly, these images record patterns of land use – such as the removal of hedgerows and even the effects of the First and Second World Wars on much older archaeological remains – from which we can judge landscape change.

Beyond military photography

Today many other aerial photographs are available for study, supplementing the information recorded on the RAF photographs. Many are vertical views which, like the RAF's, were originally taken for non- archaeological purposes. They include photographs commissioned by the Ordnance Survey for map production, mainly dating from the 1960s and 1970s, and blanket coverage of the country made for census purposes by commercial companies from the 1960s onwards. The legacy of the pioneers of aerial photography for archaeology also forms the core of several large national (and many smaller) collections of specialist oblique photographs, most of them taken with hand-held cameras.

Because most specialist oblique aerial photographs are taken specifically for archaeological discovery and survey, most people are more familiar with their use than with vertical photographs for archaeological purposes. Among other advantages, oblique images are often useful for illustration purposes, demonstrating the geographical and even strategic location of a site. They can provide a more familiar view, allowing a quick understanding of a site's layout, particularly important if the site is too large to view in its entirety from any single point on the ground.

In particular, by taking oblique photographs under suitable conditions, archaeologists can record in great detail archaeological sites visible as earthworks

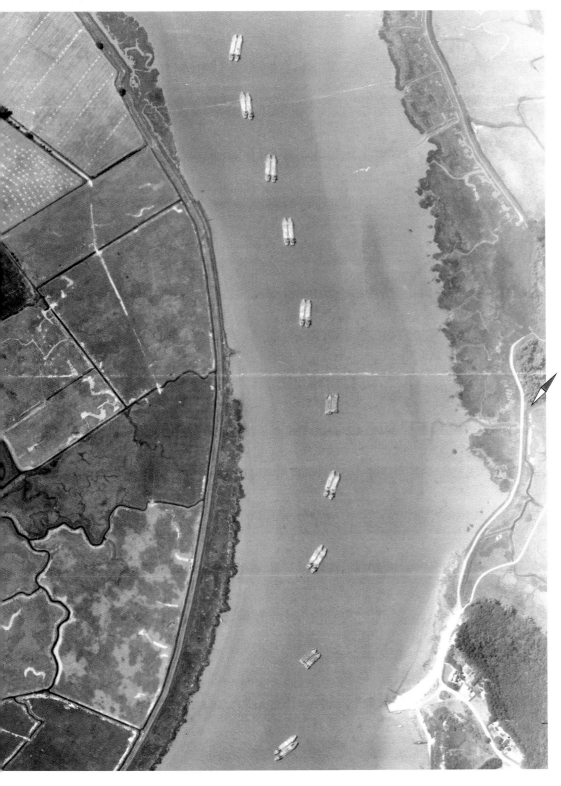

Fig 2.9 A moment in time: a dummy fleet moored in the Deben Estuary in July 1944. Such dummy vessels were built to give the impression to enemy reconnaissance that the fleet for the D-Day landings was much larger than in reality. (RAF 106G/LA23 4006 06-JUL-1944 English Heritage (NMR) RAF Photography)

(the lumps and bumps that often constitute the remains of a historic site) or cropmarks, where buried features reveal themselves through differential crop growth (Figs 2.10 and 2.11). Cropmarks can also sometimes be seen on vertical photographs which are taken for non-archaeological purposes, but only if they happen to have been taken at the right time of the year and in the presence of the right crops. Specialist aerial reconnaissance often leads to the discovery of new sites, as the archaeologist can time a

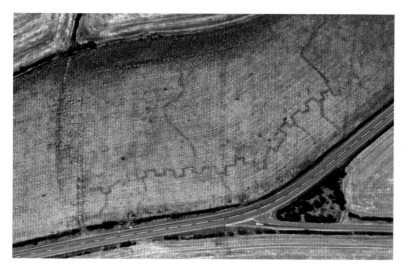

Fig 2.10 A military trench system, typical of those used in the First World War, is today visible only as a cropmark, in this case as lines of taller, lusher and greener growth above now-buried ditches. The appearance of cropmarks is dependent on prevailing agricultural practices, types of crops and their potential to become stressed in drought conditions. (NMR 17353/30 29-JUL-1999 © English Heritage.NMR)

Fig 2.11 Cropmarks are formed when buried features such as ditches or walls affect the growth of crops or other vegetation above them. Crops above ditches, which contain extra moisture, tend to grow taller and lusher and ripen more slowly than surrounding crops; those above buried walls or compacted surfaces, which restrict access to moisture, tend to be stunted and ripen more quickly. The patterns of buried archaeological features can therefore be traced in the different colours and heights of crops as viewed from the air, though they may be invisible from the ground.

reconnaissance flight so that land-use and weather conditions are conducive to cropmark formation.

Aerial photographs of the Suffolk coast are available from a number of sources. The NMR holds vertical and oblique photographs taken during and after the Second World War, as well as later oblique photographs taken for the purposes of archaeological and architectural recording. Another major source, the Cambridge University Collection of Aerial Photographs, also includes oblique and vertical coverage. Suffolk County Council holds the vertical

coverage of the county taken for census surveys, as well as oblique photographs taken by the county's Archaeological Service in the 1970s and 1980s.

From photographs to maps

OGS Crawford, who in the 1920s and 1930s pioneered the interpretation and mapping of archaeological sites recorded on aerial photographs, was far ahead of his time in understanding the need to record and collate such information, and his work has influenced the way the National Mapping Programme uses aerial photographs today. There are a number of reasons for mapping the archaeological sites and landscapes visible on aerial photographs. One is to maximise the amount of information readily available to the general public; a single interpretative map of archaeological sites may bring together data from thousands of aerial photographs. Furthermore, not all the information about a particular site may be visible on a single photograph (this is often the case for cropmarks, where the information revealed at any given time depends on land use, weather conditions and the timing of flights). Additionally, there may be restricted access to original photographs which are delicate or for which no negatives survive.

3
From prehistory to the medieval period

Prehistoric defences?

From the time when people first began to settle in one place there has been the occasional need to protect resources from others, be they hunting grounds, livestock or homesteads. However it is not until the Late Bronze and Iron Age, from about 3,000 years ago, that we begin to see settlements surrounded by substantial ditches and banks which suggest that may have been a consideration in their construction. An increasing population, pressure on resources and changes in society may have created a need to demarcate and even defend property.

The most impressive defended sites of the prehistoric period are the large Iron Age hillforts of central and southern Britain, built over 2,500 years ago. These forts, with their large enclosing banks and ditches, are thought to have been constructed as much to emphasise wealth and status as for defence. Undoubtedly the British population at this time had contact with people from Europe, but it is unlikely that coastal raids were of any significance. It is more likely that the defences, if that was their intended function, were constructed as protection from other tribes.

Numerous prehistoric settlement sites along the Suffolk coast are visible as cropmarks on aerial photographs, but no obviously defended prehistoric sites, similar to the hillforts of central and southern England, are known (there remains a potential for further discoveries through aerial survey, however). Some of the Suffolk sites are surrounded by ditches but in general these do not appear substantial enough to represent defences (Fig 3.1).

There are several possible explanations for the apparent lack of large prehistoric defended settlements in Suffolk. It has been suggested that sites like the hillforts of Wiltshire and Dorset would have been less visually impressive in the relatively flat landscapes of East Anglia, although the differences may arise from more general variations in political or economic conditions. Additionally, erosion and salt-marsh reclamation in later periods may have destroyed some of the evidence for large defended coastal sites.

The edge of the empire

Before the Roman invasion, defence in Britain was probably largely a matter of protecting tribal areas against raiding neighbours. When Claudius and his army conquered Britain in AD 43, they introduced a centralised system of government and with it the need to defend the province as a whole, which naturally involved defending the coast. In the early years of Roman Britain, however, the construction and location of coastal installations were related to supply routes, the importation of goods and the harbouring and maintenance of the Roman naval fleet, rather than to defence alone, and these installations were in Kent and on the South Coast.

While inland forts from the immediate post-conquest period are known at Pakenham and Coddenham, no Roman military sites are visible on the Suffolk coast today,

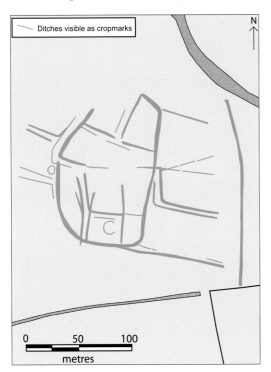

Ditches visible as cropmarks

N

0 50 100
metres

Fig 3.1 Many prehistoric settlement sites visible as cropmarks on aerial photographs of the Suffolk coast are surrounded by ditches, such as this one at Harkstead, although they do not seem substantial enough to have provided an effective defence against attack, even where they are accompanied by banks. Some enclosed settlements may also have had a palisade fence, perhaps for defence or for stock control. (© Crown copyright. All rights reserved. English Heritage 100019088. 2007)

11

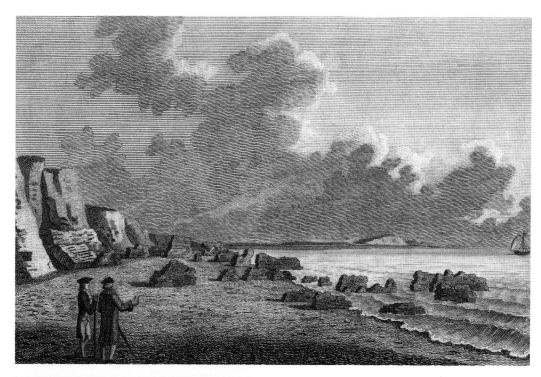

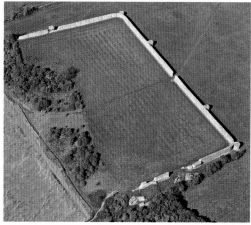

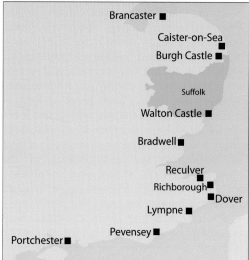

although we do not know how many have been lost to coastal erosion. For example, a place named in documentary sources as Sitomagus, traditionally equated with Dunwich, may have been a port with government and military functions. The only Roman coastal fort thought to have existed in Suffolk, now referred to as Walton Castle, stood on the low cliffs at Felixstowe until its last remaining walls fell into the sea in the early 18th century. The fort is mentioned by a number of antiquarians, and underwater explorations in the 1960s apparently identified the remains of Roman walls just offshore. Antiquarian sketches suggest that it may have been very similar to the Roman fort at Burgh Castle in Norfolk (Figs 3.2 and 3.3).

Along with Burgh Castle, Walton Castle was part of a chain of 11 Roman forts constructed in the 3rd and 4th centuries AD along the south and east coasts of England, known as the 'forts of the Saxon Shore' (Fig 3.4). These are traditionally thought to have been built to protect this vulnerable coast against northern European pirates, although doubts remain as to whether this was their primary purpose; they probably had a variety of roles as military ports and distribution centres.

After centralised Roman rule ended, Britain returned to a more fragmented society which could not prevent the Germanic incursions and settlements in East Anglia in the 5th and 6th centuries AD. The Kingdom

of the East Angles was in turn subject to raids and eventual invasion by the Danes in the 9th and 10th centuries. Ipswich's first ditched defences were probably built by the Danes in the 10th century, and perimeter defences were also built by a number of other Suffolk coast towns during this period.

Castles, coasts and kings

In the medieval period after the Norman Conquest of 1066, attacks by raiding parties from Europe were frequent, particularly along the English Channel, increasing in the 14th century as relations with France deteriorated. These were not determined attempts at invasion and did not give rise to a national strategy of coastal defence. Individual towns constructed their own defences, and coastal castles were in reality intended to deal with internal problems rather than overseas threats.

The only remains of an early defended site that are visible above ground on the Suffolk coast today belong to the medieval period. These are the remains of Orford Castle, built by Henry II between 1165 and 1173. Other early castles were constructed at Ipswich and – according to documentary references – within the remains of the Roman shore fort at Walton Castle, although both had been demolished by the time Henry built his castle at Orford.

He did so for two main reasons, first and probably most importantly to reassert his authority in East Anglia, as the lords in the

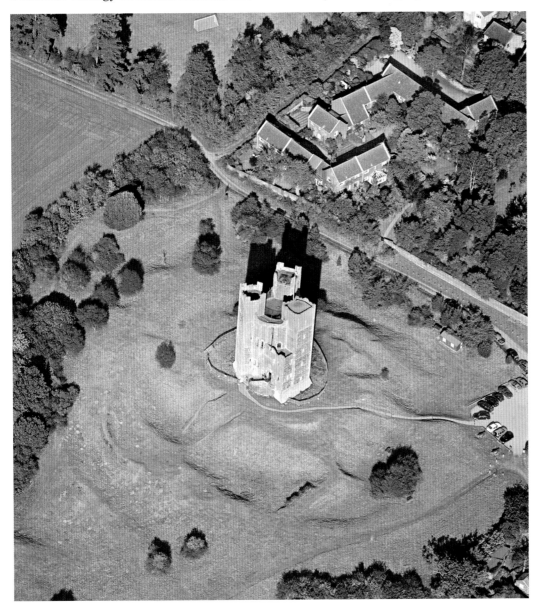

Fig 3.5 Only the keep remains standing at Orford Castle today. The surrounding earthworks are a combination of the remains of a ditch, the former position of a curtain wall and later effects of quarrying and landscaping. (NMR 21852/04 19-OCT-2002 © English Heritage.NMR)

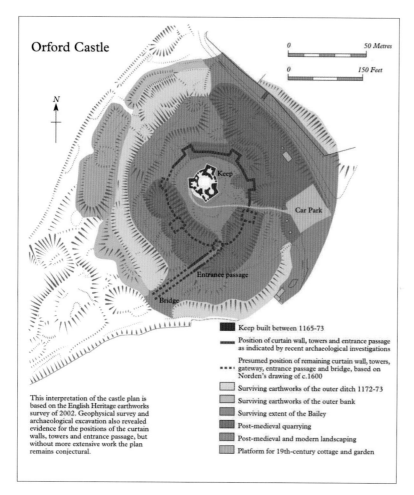

Orford Castle

0 — 50 Metres

0 — 150 Feet

N

Keep

Car Park

Entrance passage

Bridge

■ Keep built between 1165-73

— Position of curtain wall, towers and entrance passage as indicated by recent archaeological investigations

■■■ Presumed position of remaining curtain wall, towers, gateway, entrance passage and bridge, based on Norden's drawing of c.1600

Surviving earthworks of the outer ditch 1172-73

Surviving earthworks of the outer bank

Surviving extent of the Bailey

Post-medieval quarrying

Post-medieval and modern landscaping

Platform for 19th-century cottage and garden

This interpretation of the castle plan is based on the English Heritage earthworks survey of 2002. Geophysical survey and archaeological excavation also revealed evidence for the positions of the curtain walls, towers and entrance passage, but without more extensive work the plan remains conjectural.

Fig 3.6 This plan of Orford Castle is based on an earthwork survey undertaken by English Heritage in 2002 as well as on excavation and geophysical survey. Further investigations are needed to confirm this interpretation. (© English Heritage)

Fig 3.7 This reconstruction drawing of Orford Castle by Frank Gardiner, showing how it may have looked in 1300, is based on the English Heritage survey (see Fig 3.6) and on early illustrations. The positions of the lost towers and curtain wall are inferred from a survey by Norden in 1600–01. (© English Heritage)

ing the coast against possible threats from Europe. Its location also helped it to become an important staging post on the East Coast.

Only Orford's impressive keep survives today, although the earthwork remains of the bailey and surrounding ditch are clearly visible from the air, muddled in with later quarrying and landscaping on the site (Fig 3.5). The design of the castle was unique and suggests that it was constructed as much as a symbol of royal power and status as a military stronghold. The polygonal keep with its three towers was a new and dramatic design, but one which may have given little defensive advantage. The curtain wall, with its mural towers, probably provided the defence in depth that allowed the keep to become a larger expression of strength, power and fashion (Figs 3.6 and 3.7).

The castle remained important into the 13th century but by the middle of the 14th century it was no longer a royal castle. By the 16th century it was empty, used as little more than a signalling station and landmark for navigation. Through the later medieval period coastal erosion processes caused the shingle spit of Orford Ness to lengthen, making the port of Orford difficult to access and causing the decline of its fishing industry. During the Second World War the keep was used as an observation post.

The next chapter deals with the post-medieval period, from the mid-16th century onwards. This period saw great change in coastal defence as a result of developments in military technology and threats arising from increasingly complicated political conditions in continental Europe. In contrast to the piecemeal defence pattern of the medieval period, the first countrywide strategy for coastal defence was developed by Henry VIII in the mid-16th century.

region had become much too powerful. Construction of the royal stronghold at Orford was accompanied by the demolition of the unauthorised castle of the powerful earl, Hugh Bigod, at Walton Castle, changing the balance of power. The second reason centred on Orford's strategic coastal position, which meant that a castle there could easily be provided with troops and supplies and could play an important role in defend-

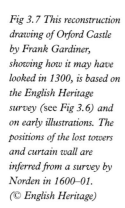

4
The 16th to 19th centuries

Threats from abroad

Henry VIII's decision in 1534 to appoint himself Supreme Head of the Church of England, and the subsequent dissolution of the monasteries, is generally accepted as the end of the medieval period. By this time the development of more effective gun technology had rendered the old methods of defence, embodied in medieval castles, obsolete. New architectural designs were needed. The pattern of defence construction in Britain for the period 1540–1900 was, in simple terms, reactionary. New defences were built to meet new political or technological threats, only to be rapidly abandoned when the danger receded. The majority of these threats came from other European countries, though some arose within British colonies further afield, as during the American War of Independence. Throughout this period the floating 'wooden walls' of the Royal Navy were Britain's critical first line of defence against invasion.

When Henry VIII (Fig 4.1) broke away from the Catholic Church so that he could divorce Catherine of Aragon, he not only made an enemy of Holy Roman Emperor Charles V, Catherine's nephew, but provided a reason for the powerful Catholic countries of Europe – France and Spain – to unite against him with the common goal of restoring Catholicism in England. Henry's actions had made England much more vulnerable to invasion and led him to develop the country's first modern national strategy for invasion defences.

It would have been an impossible task to protect the whole of England's coastline against an invasion attempt. Henry's defence strategy involved the protection of key anchorages such as the Humber and the Thames, which if captured could be used to launch a full-scale invasion. Consequently much of the Suffolk coast was left unprotected during this time, although certain coastal towns such as Aldeburgh received guns in order to allay the fears of the local inhabitants.

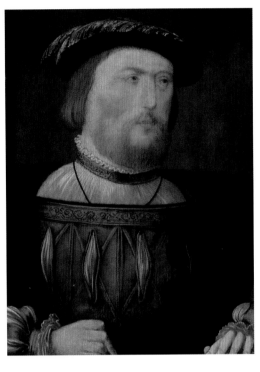

Fig 4.1 Henry VIII, because of the break with Rome and the threat of a Franco–Spanish invasion, commissioned the first national system of coastal fortifications in England. (NPG 3638, National Portrait Gallery, London)

Harwich Haven, between Harwich and Felixstowe, was identified as a key strategic point on the East Anglian coast. This is where the rivers Orwell and Stour meet and flow into the North Sea, marking the border between the counties of Suffolk and Essex (Fig 4.2). Harwich Haven was important because it was the only large, safe natural harbour between the Thames and the Humber. It was also home to one of Henry's naval dockyards. It remained a key strategic point on the East Anglian coast until after the Second World War, and the development of the Haven's defences is central to the story of Suffolk's defences in the post-medieval period.

Despite the threat from Catholic Europe, no immediate action was taken to protect the Haven. Eventually, after a visit by Henry VIII himself in 1543, two earthwork-and-timber bulwarks were constructed on Landguard Point on the Suffolk side of the Haven, and another three at Harwich on the Essex side. The placement of guns on Landguard Point was particularly important as the only

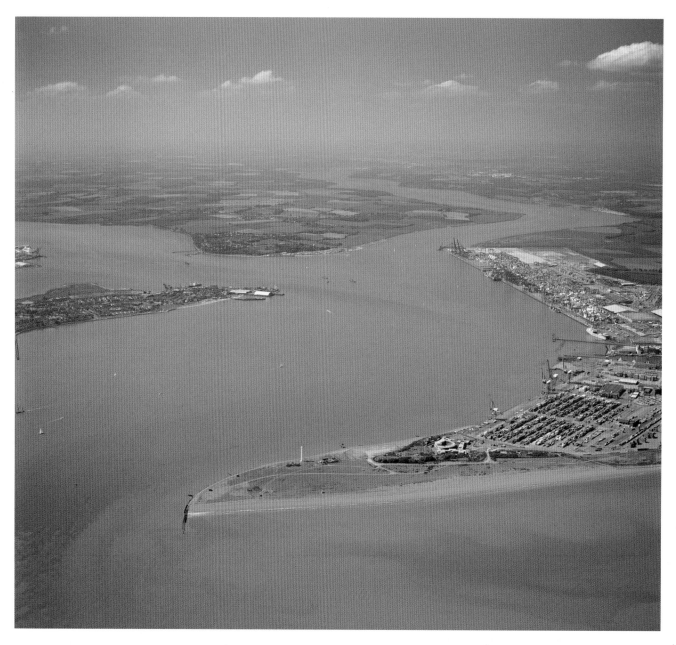

Fig 4.2 Harwich Haven, looking west. In the foreground is the shingle spit of Landguard Point, with the post-medieval fort and the modern container port at Felixstowe. In the distance, Harwich is visible to the left of the photograph and Shotley Point in the centre. The Stour and Orwell rivers enter from the left and right, respectively. (NMR 23526/14 19-MAY-2004 © English Heritage.NMR)

deep-water access to the Haven runs very close to the end of the promontory. These defences were never tested and, as is typical of the period, the Haven's bulwarks were neglected as the threat from Europe receded. By 1552 the defences had been dismantled.

Although the Landguard Point bulwarks were reinstated in 1588 in anticipation of the arrival of the Spanish Armada, the years of peace following its defeat witnessed a general neglect of the country's coastal defences. Nevertheless it was proposed that a new fort should be built at Landguard Point, perhaps reflecting the continuing importance of Harwich Haven even in times of relative peace, and concern over

ongoing raids by pirates operating out of Spanish-occupied Dunkirk.

The new fort, built between 1625 and 1628, incorporated some of continental Europe's newest ideas in military design. Constructed mainly of earth but with some brick, it was square with an extremely low profile and acute-angle bastions at its four corners (Fig 4.3). The original design was by a Dutch military architect, Simon van Cranvelt, although he died before the fort was completed. The fort was alternately maintained and neglected according to waxing and waning invasion threats, although it was successfully held for Parliament throughout the English Civil War

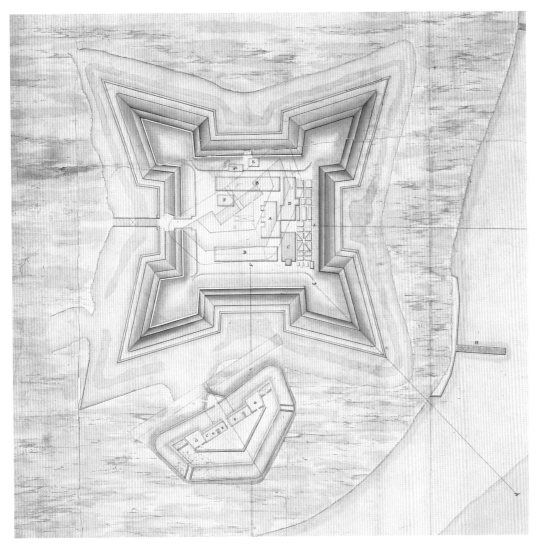

Fig 4.3 A plan of Landguard Fort (probably by J Brooks, engineer, c 1715). The plan of the 1620s fort, with its square shape and acute-angle bastions, is clearly visible. A plan of the much simpler, battery-like fort of the early 18th century has been attached, possibly at a later date. (WO78/1452 (1) The National Archives UK)

(1642–49) and survived the First Dutch War (1652–54) unscathed.

The Dutch tried to capture Landguard and take control of Harwich Haven during the Second Dutch War (1665–67). On 2 July 1667 a raiding force of 1,500 to 2,000 men landed on the coast at Felixstowe. Thanks to additional outer defences, rapidly constructed earlier that year by military engineer Sir Bernard de Gomme, and the fact that the Dutch ships could not sail close enough to provide artillery cover, the attempt failed and the Dutch beat a hasty retreat. De Gomme – himself Dutch – also improved Harwich's defences at this time. (The defence of the fort in 1667 was undertaken by Captain Nathaniel Darrell, after whom a battery at Landguard Fort was named at the end of the 19th century.)

During the first half of the 18th century, Europe was in the grip of escalating naval conflicts. France believed that conflicts in the colonies, particularly in North America, could be resolved by bringing the battles closer to home. The developing situation with France and the need for larger guns precipitated two major redesigns at Landguard. The first, in 1717–1720, essentially turned the fort into a glorified battery with a barrack block attached. The second, in 1745–1750, resulted in the pentagonal plan still clearly visible on aerial photographs today (Fig 4.4) despite later alterations to the south-west side. A battery that came to be known as Beauclerk's battery was also constructed outside the front of the main fort at this time, to support new guns which were too large to be mounted within the fort.

As European tensions resurfaced later in the century during the American War of Independence, invasion was again considered a possibility. A large military camp, earthwork batteries and trench defences were established on Landguard Point at this time.

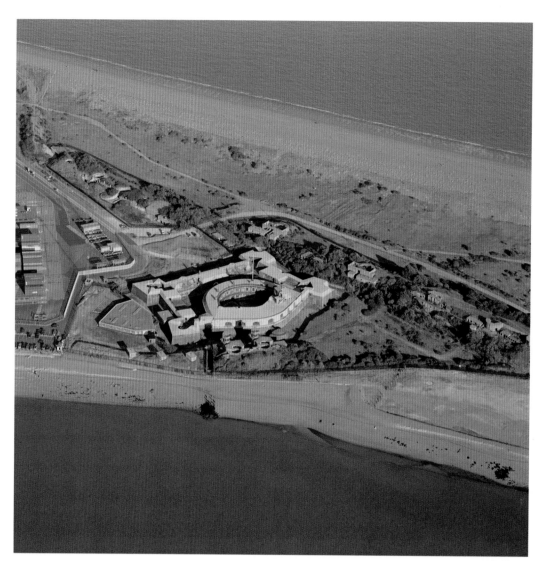

The key to Europe

A potentially much greater threat was brewing in Europe at the end of the 18th century, in the form of Napoleonic France. Britain and France had been at war since 1793 and Napoleon Bonaparte, seeing an invasion of Britain as the key to supreme control over Europe, had begun to plan for one. In 1803 Britain renewed hostilities in response to Maltese protests over France's 1798 capture of the island, and Napoleon began amassing an invasion fleet and army.

In Britain it was decided that a new coastal defence strategy was needed. This would include a chain of forts to be built along the coast, which in turn prompted a survey to assess potential locations and vulnerable points. One Captain William Ford suggested that the forts should be squat, circular towers similar to one that he had seen resist

bombardment by the Royal Navy at Mortella Point in Corsica in 1794. In what is probably a derivation of the name Mortella, these coastal fortifications became known as Martello Towers.

Ultimately 103 Martello Towers were built in England, in two phases. Between 1805 and 1808, 74 towers were constructed along the South Coast. A further 29 went up on the East Coast, including those constructed in Suffolk, between 1808 and 1812. They were located at regular intervals, allowing them to cross fire with one another and to protect vulnerable points and gun batteries. The construction of the East Coast towers was important for two reasons: firstly to stop an invasion force attempting an out-flanking manoeuvre on London, and secondly to discourage a crossing to the deeper harbours of the East Coast which, though more dangerous, could be undertaken

in much larger ships, potentially delivering a larger invasion force. The construction of Martello Towers came to an end in 1812 when Napoleon's defeat in Russia finally loosened his grip on Europe.

The small, round towers were brick-built and covered in stucco. They stood about 33ft (10m) high with walls 8ft (2.4m) thick at the base, tapering towards the top, with staircases located between outer and inner walls. The thickness of the walls at the base of the tower made the structure more difficult to undermine. Access was on the first floor via a rope ladder – or a drawbridge if the tower had a moat – in order to stop enemy troops gaining entry in the event of a successful landing. Typically a central column supported the roof, which had a quatrefoil parapet where the gun was located.

The East Coast towers, located between Clacton in Essex and Aldeburgh in Suffolk, were generally larger in diameter than the South Coast towers – allowing them to support more guns – and more ovoid in shape. The ovoid shape meant that the towers could be thicker on the seaward side, providing greater protection against artillery bombardment (Figs 4.5–4.8).

Of the East Coast towers, 18 were in Suffolk, although only 11 remain today, the result of coastal erosion or in some cases deliberate demolition. Most of the Suffolk towers were built to the standard design described above, with two notable exceptions. Tower N at Walton Ferry, the site of which is now beneath the Felixstowe container port, was built with an unusually large moat containing a cunette, or narrow trench (Figs 4.9 and 4.10). These extra defensive features may reflect the tower's strategic location at Harwich Haven, although the other towers around the Haven did not have these features. The second exception, at Slaughden, near Aldeburgh, is unique in Martello Tower design, being quatrefoil in shape to carry four guns (Fig 4.11). This was the final and most northerly tower to be built in the East Coast chain.

Figs 4.5–4.8 Martello Towers on the Suffolk coast. Fig 4.5 (below, left) The hamlet of Shingle Street with Martello Tower AA in the foreground. (NMR 21851/11 19-OCT-2002 © English Heritage.NMR) Fig 4.6 (below, top) Martello Tower W, East Lane, Bawdsey. (NMR 21831/31 19-OCT-2002 © English Heritage.NMR) Fig 4.7 (below, centre) Martello Tower T, Felixstowe Golf Course. (NMR 21831/16 19-OCT-2002 © English Heritage.NMR) Fig 4.8 (below, bottom) Martello Tower U, Felixstowe Ferry. (NMR 21831/17 19-OCT-2002 © English Heritage.NMR)

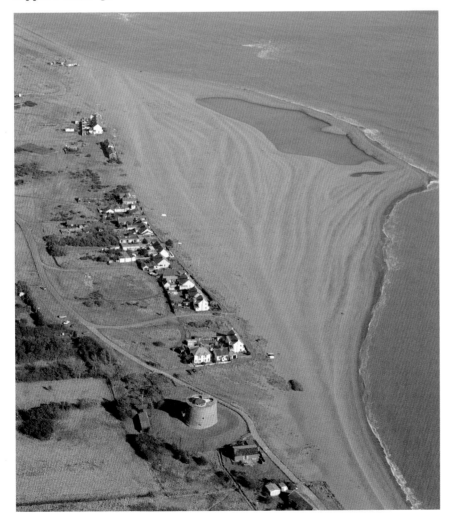

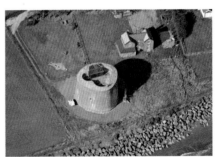

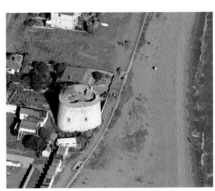

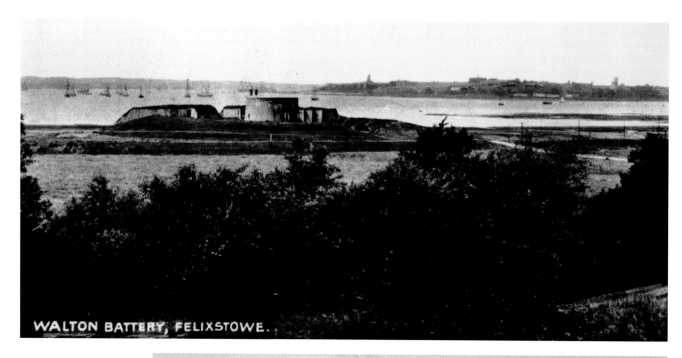

WALTON BATTERY, FELIXSTOWE.

Fig 4.9 View c 1910 of the
Martello Tower N and gun
battery with Harwich in
the distance across Harwich
Haven (Suffolk Record
Office, Ipswich branch
K681/1/475/16)

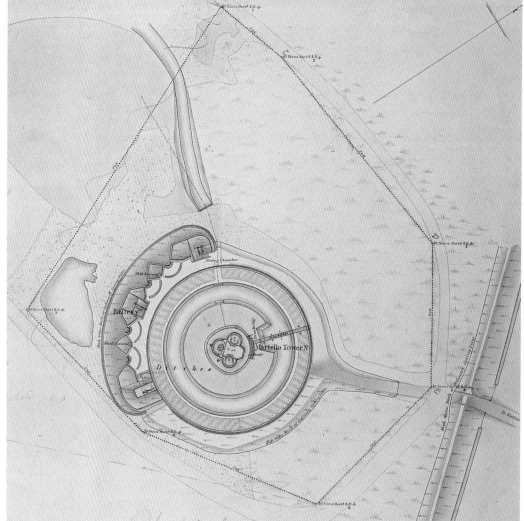

Fig 4.10 Plan of the
Martello Tower N and gun
battery, Walton Ferry,
Felixstowe in 1866
(WO78/2754 (10),
The National Archives
UK)

Although the chain of Martello Towers continued as far north as Aldeburgh, Harwich Haven remained the key port on the East Anglian coast during the Napoleonic Wars. The Haven was protected by five towers which crossed fire between Shotley and Landguard Point. Some alterations were also made to Landguard Fort. However, the major development in the Haven's defences during this period was the construction of the Redoubt (Fig 4.12) in Harwich on the Essex side. This fort worked in conjunction with the guns on the Suffolk side, on the Martello Towers and at Landguard, to provide full defensive cover for the Haven.

A new century, a new enemy

For the rest of the 19th century relations between Britain and France remained difficult as a result of political tensions and armaments advancements by both countries, including the development by France of ironclad warships. A number of invasion scares led to the publication in 1860 of the *Report of the Commissioners Appointed to consider the Defences of the United Kingdom* and to a massive programme of fort construction under the

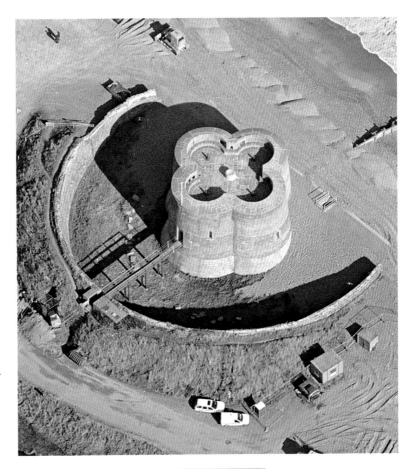

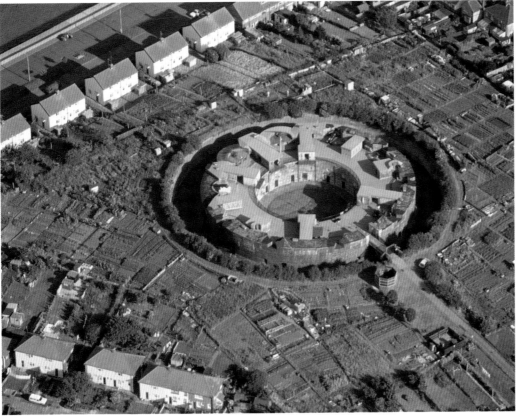

Fig 4.11 Slaughden Martello Tower (Tower CC), near Aldeburgh, in 2002. This was the last Martello Tower to be built, and the most northerly in the East Coast chain. (NMR 21836/01 19-OCT-2002 © English Heritage.NMR)

Fig 4.12 The Redoubt at Harwich, built between 1807 and 1810. The battery had 10 guns and was intended to cross fire with Landguard Fort and the various Martello Towers around Harwich Haven. (NMR 23161/11 22-JUL-2003 © English Heritage.NMR)

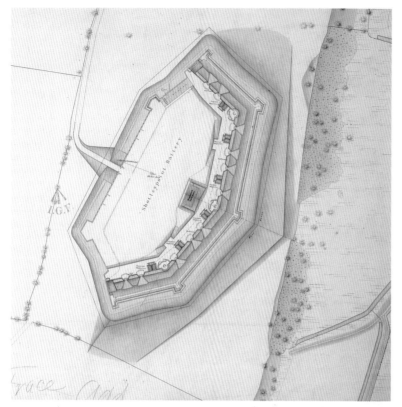

supervision of the Prime Minister, Lord Palmerston. Though little new work was undertaken on the Suffolk coast, defences and guns around Harwich Haven were upgraded and in 1862 a battery was built at Shotley Point (Fig 4.13).

In the 1870s Landguard Fort was redesigned yet again, and by the time the alterations had been completed only the outer ramparts of the pentagonal fort remained. It was during this period that the distinctive, semicircular casemated battery was built, with embrasures equipped with wrought-iron shields. At the centre, in front of the battery, was a caponier, an ingenious but unnecessary shielded construction meant to provide flanking fire along the ditch (Fig 4.14). Despite these alterations it was felt that the Haven was still not adequately protected, and at the end of the 19th century the main armament was mounted in two new batteries outside the fort itself, known as the Left Flank and Right Flank batteries.

Finally, after years of preparing for a French invasion, the start of the 20th century heralded new dangers from an entirely different direction: Germany.

Fig 4.13 An 1863 plan of Shotley Point Battery, now largely demolished. (WO78/2776 (5) The National Archives UK)

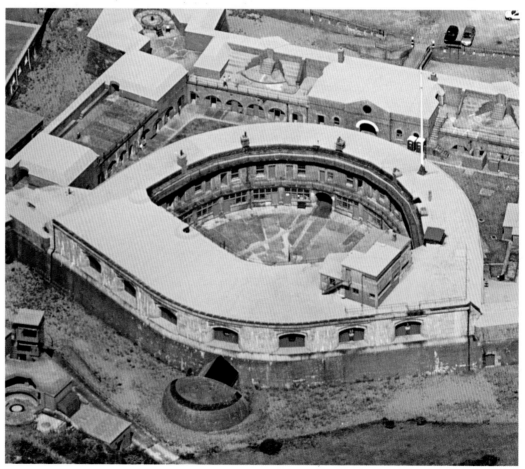

Fig 4.14 Landguard Fort's casemated battery, completed in 1871. Casemates were covered vaults for housing guns. The semicircular structure in the foreground is a caponier, designed to provide flanking fire along the ditch. Alterations at this time completely erased the internal features of the 18th-century fort. (NMR 23161/16 22-JUL-2003 © English Heritage.NMR)

5

The 20th century up to the Second World War

This chapter looks at how Suffolk's coastal defences reflected and responded to changing military and technological developments in the complex political world of the early 20th century. At the turn of the century Britain's first and foremost line of defence continued to be the Royal Navy, but events were about to thrust Suffolk into a new position of strategic importance. Britain's 19th-century antagonisms with France gave way to recognition of the benefits of reconciliation, culminating in the historic Entente Cordiale of 1904. Germany was now the source of British invasion fears.

Germany's empire was limited, but Kaiser Wilhelm II wanted a 'place in the sun'. His expansionist attitude had already unnerved France and Russia, who had signed an alliance in 1894. German imperial ambitions required a strong navy, threatening Britain's dominance of the seas. A naval arms race ensued.

With most of Britain's existing coastal defences facing southwards towards France, its new ally, the first decade of the new century found the East Coast effectively defenceless against the new enemy. International politics had placed the East Coast, including Suffolk, in a potentially vulnerable position.

The decline of monumentality

By the late 19th century modern naval artillery could easily destroy even the sturdiest stone-and-concrete fort from a great range, making such defences effectively redundant. For this reason the construction of new defences seemed pointless and, because the British government felt safe under the protection of the Royal Navy, no new coastal fortifications were built in Suffolk in the early years of the 20th century.

As Germany became a threat, however, the Royal Navy decided the priority was the protection of naval ports and anchorages. Coastal defence was improved around Britain's major East Coast ports, including the Humber and Tynemouth. With its naval base, Harwich Haven had assumed even greater strategic importance, and the defences in the Landguard Fort area were modernised (Figs 5.1 and 5.2). New quick-firing batteries were built to face the threat posed by fast German torpedo boats. The situation was not to change significantly until the outbreak of the First World War.

The First World War

Despite a self-imposed policy of 'splendid isolation' and the efforts of the British Foreign Secretary, Sir Edward Grey, to maintain the peace, the Liberal Government of Herbert Asquith was drawn into the 'Great War' in August 1914 by the complicated web of treaties which had been fashioned over many years to maintain the balance of power in Europe.

Anti-invasion defences

As the conflict in Europe progressed, Britain's wartime coalition government confronted the threat of invasion. Anti-invasion strategies still relied primarily on a naval blockade, but the possibility of a successful landing was acknowledged in the provision of up to 600,000 men for home defence: 300,000 to man fixed coastal defences and up to 300,000 in a mobile force to man a series of defensive stop lines. Key areas on the East Coast were reinforced after the German fleet shelled Great Yarmouth in November 1915.

Full coastal defences were only to be constructed when invasion was imminent. Fieldworks such as trenches were limited to strategically important ports, with additional anti-invasion defences constructed at a few coastal towns such as Felixstowe (Fig 5.3). The author Sir Henry Rider Haggard described the scene on the Suffolk coast:

> 15th August, 1915: Yesterday I motored to Southwold and Lowestoft. Southwold is deserted. No one on the beach, except a few soldiers and their girls. Barbed wire defences everywhere, also trenches and sandbags

Fig 5.1 *Following the outbreak of the First World War, Landguard Point's coastal defences were enhanced by the construction of Brackenbury battery, seen here in 1940. This two-gun battery north of Felixstowe compensated for a shortage of powerful guns north-east of Landguard Fort. (MSO 31032/PO-2044 05-JUL-1940 English Heritage (NMR) RAF Photography)*

Fig 5.2 *Brackenbury battery 1941. (RAF 2B/BR168 9 18-DEC-1941 English Heritage (NMR) RAF Photography)*

though what the use of them is I do not know as they look to me as though they could easily be turned by an invading force taking advantage of the deep water to land here – if it can.

(Higgins (ed), 1980; 39)

But by 1916 the struggling Royal Navy, weakened by losses, was too slow to prevent an invasion and fears were growing, particularly in Suffolk, following the hit-and-run shelling of Lowestoft by German battle cruisers.

A means of containing an enemy landing force, giving home forces time to respond, was required. British troops had used defended blockhouses to this end during the Boer War, and in the stalemate of trench warfare Germany had proven the effectiveness of purpose-built, anti-infantry machine-gun emplacements, or 'pillboxes' as they became known. Between the better defended Essex beaches and the inhospitable Norfolk coastline, the General Staff saw the low shores of Suffolk, from Aldeburgh to Lowestoft, as particularly vulnerable to invasion. From 1917 these were some of the first places in Britain to see pillboxes adapted as an anti-invasion measure. A number were built in key positions along the coast, with barbed wire entanglements and extensive trenches providing extra depth of defence. Fortunately the feared invasion never took place, and this limited system of defences was never put to the test.

The war in the air

The First World War saw a new threat arise in the form of aerial warfare. Although aeroplane technology was rapidly developing, the greatest direct threat to Britain during that war came from the large airships developed in Germany under the direction of Count von Zeppelin. The first airship attacks came on the East Coast at Great Yarmouth in January 1915, killing two people and injuring thirteen. Frequent raids elsewhere in Britain followed. Airships were difficult to steer and although the attacks caused panic and some civilian casualties, they caused little significant damage to military targets. However, because airships crossing the North Sea often used Orfordness lighthouse as a navigational aid, the Suffolk coast suffered more than most as the airships dropped their bombs after regrouping.

Fig 5.3 A pillbox and anti-invasion defences on the Felixstowe seafront in the First World War. (Suffolk Record Office, Ipswich branch K681/1/158/234)

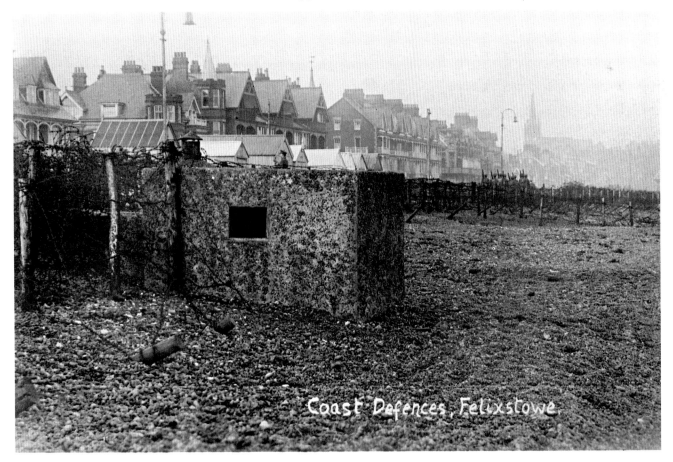

Coast Defences, Felixstowe.

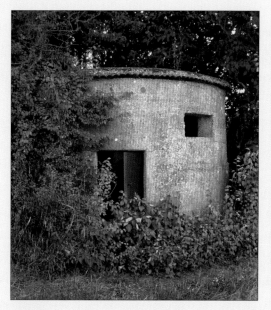

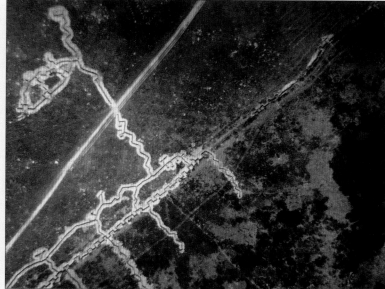

(© Roger J C Thomas)

(The Hammond Collection)

Pillboxes and trenches

Some of the earliest British pillboxes were constructed at vulnerable locations in Suffolk, at Hollesley, Sizewell, Bawdsey and Kessingland. Some faced inland, protecting sensitive ports from attack by enemy troops which had landed elsewhere on the coast. Many were built using a tough new building material, reinforced concrete. In Suffolk most were circular in plan, resembling pillboxes of the day, giving rise to their popular nickname (*above*).

Trenches similar to those dug in the battlefields of Europe were also dug along the Suffolk coast. Trenches of this date were typically crenellated or stepped in form, designed to prevent crossfire along the trenches and limit the effects of artillery blasts whilst still providing secure firing points and communication routes (*above*).

Many Suffolk trenches were probably dug on 'waste ground' such as heaths. With the subsequent cultivation of such land some of these trenches have been rediscovered as cropmarks, as here at Levington Heath (*below, left and right*).

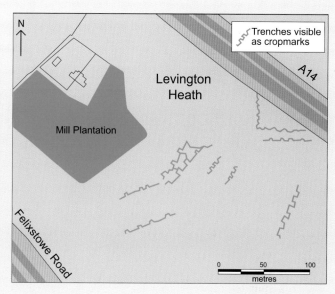

(© Crown copyright. All rights reserved. English Heritage 100019088. 2007)

(SFU/11548/CQ/31 21-JUL-1975 © Suffolk County Council)

Anti-aircraft artillery

What could be done to defend Suffolk's coast from this new threat? Military opinion was split between anti-aircraft guns and armed aircraft ('fighters'). Specialist artillery had been developed in the 19th century to shoot down tethered reconnaissance balloons, but Zeppelins flew at extremely high altitudes and, although they were slow, finding the range of such a moving target was a new problem for artillery. Specialised guns did not exist for this defensive role; existing artillery was adapted for high firing, but with limited success. The location of the guns was also a problem. The raids were too infrequent for the installation of fixed guns at all possible targets to be economical. Mobile guns were one answer, as the Zeppelins were slow enough for guns to be mounted on lorries and driven to areas under attack.

Most military experts thought the best defence against enemy aircraft would be other aircraft, so Britain entered the war with almost no anti-aircraft guns in place. A few military targets did receive fixed guns; in Suffolk an anti-aircraft command area was focused on Harwich Haven, with artillery at Landguard Fort, Landguard Common, Walton Ferry, Shotley and Trimley Heath. But little trace of these batteries survives in even the earliest aerial photographs, and they are known only from written records.

Anti-aircraft weaponry did improve as the war progressed, forcing back the Zeppelin raiders by 1917, only to be faced with attacks from faster, smaller, harder-to-hit Gotha and Giant aeroplane bombers.

A force in the air

Because Britain's military establishment had been initially sceptical of powered flying machines, early experiments lagged behind those of France and Germany. The Royal Flying Corps (RFC), formed in 1912, was initially split into a military and a naval wing. At the outbreak of war, with the Royal Navy responsible for home defence, military logic placed the RFC's naval wing – subsequently renamed the Royal Naval Air Service (RNAS) – in charge of aerial home defence. The rest of the RFC followed the army to Europe.

This split air service proved inefficient, and a new Royal Air Force (RAF) would be formed in 1918, but at the outset of the war the limited aircraft of the RNAS, mostly based at a few East Coast airfields, provided the country's sole air defence. Important

Suffolk Coast air stations were located at Felixstowe and Aldeburgh, soon to be joined by an experimental air station at Orfordness. In October 1915 an aerodrome was commissioned just west of Aldeburgh near the hamlet of Hazlewood, a satellite landplane Night Landing Ground for the RNAS seaplane base at Great Yarmouth.

Felixstowe Air Station was commissioned in 1913 as a RNAS seaplane base. From the start of the war the seaplanes' main role was patrolling for German U-boats, particularly after 1917 when the base began 'Spider's Web' patrols to fight the U-boats' accelerated mine-laying campaign. By 1917 the threat of Zeppelin bombing raids over Britain had largely disappeared, although seaplanes occasionally encountered airships when patrolling near the Low Countries.

Suffolk played an important part in the development of the aeroplane as a defensive weapon. In 1915 the Central Flying School at Upavon, Wiltshire, relocated the Armament Experimental Flight of the Experimental Flying Section to Orfordness. Number 37 squadron formed at Orfordness in 1916 but quickly merged with the island's experimental squadron. The following year the squadron moved to Martlesham Heath, the research establishment remaining at Orfordness and operating as a satellite airfield to the larger base.

Research at the base centred on three areas: navigation, armament research and bombing technology. Pioneering experiments were also carried out by Lieutenant Waldon Hammond on the use of oblique aerial photographs for military reconnaissance (Fig 5.4), but these trials were not followed up until the Second World War.

Important work on the dangerous practice of night-flying was carried out on the Ness. The experimental squadron occasionally put their research directly into practice, as on the night of 16 June 1917 when aircraft from Orfordness shot down Zeppelin L.48 over Theberton, near Leiston (Fig 5.5).

After the armistice

Following the armistice of 1918 most anti-invasion defences were quickly removed and other sites such as aerodromes were abandoned, with implications for their survival and identification on aerial photographs. In contrast to later defences, First World War anti-invasion defences can be difficult to identify, for several reasons.

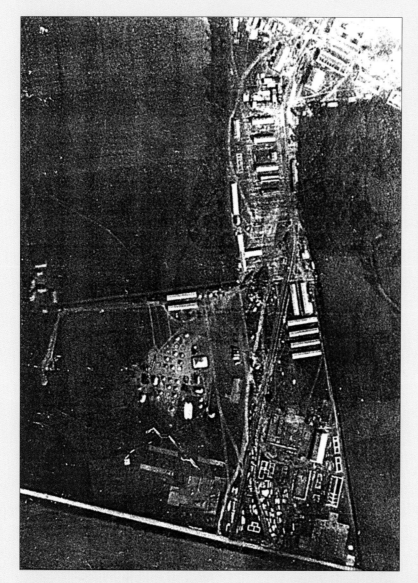

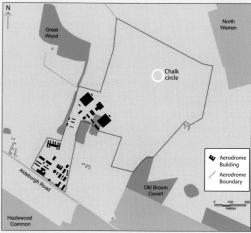

(Reproduced with kind permission of Mrs Joanna Turner)

Hazlewood Aerodrome

Initially the Hazlewood base accommodated only two officers and twelve men who, from 1915 to 1916, flew anti-Zeppelin patrols as far north as Southwold and as far south as Felixstowe. Following the formation of the RAF in 1918 the airfield was converted into an Anti-Submarine Observers' School. The airfield and base were extended, as seen on the photograph and plan from 1918 (*above left and right*), with new buildings for staff and up to 150 students at a time. However, the camp was never completed and the aerodrome was operational only until the autumn of 1919. The foundations of a number of camp structures can be seen as parchmarks (where grass, starved of moisture, has died over buried foundations) on recent aerial photographs (*right*).

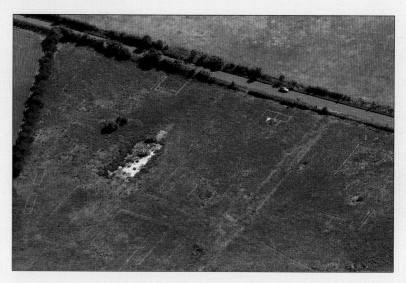

(NMR 23966/026 27-JUN-2006 © English Heritage.NMR)

Felixstowe RNAS Base

A number of seaplane hangars were built on the shore of the River Orwell, with slipways and jetties running down to the water. The two original sheds were demolished in 1913, but during the First World War three smaller hangars with curved roofs, and three much larger hangars, approximately 90m × 50m in size, were built behind them parallel to the water's edge. These are still visible in the 1948 photograph here (*right*). By 1969 they were being subsumed into the expanding container port (*below, left*). One of the larger hangars survives today, used by Felixstowe Dock Company in a much altered form, although it faces an uncertain future as the port continues to expand (*below, right*).

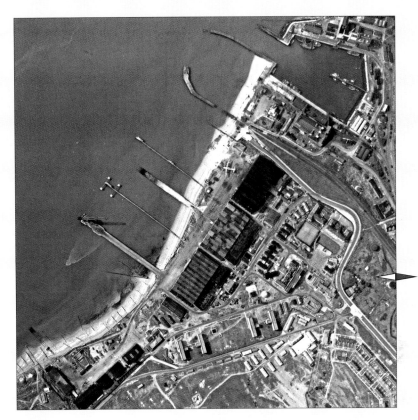

(RAF 58/115 5166 30-AUG-1948 English Heritage (NMR) RAF Photography)

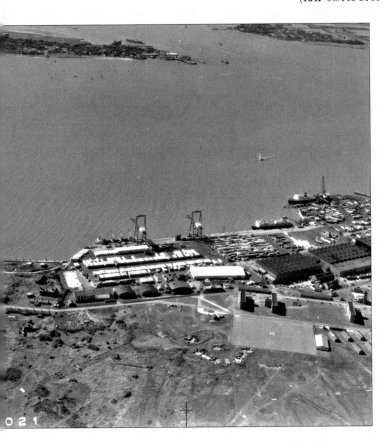

(bbs_446_021 01-JAN-1969 © Pre-Construct Archaeology (Lincoln))

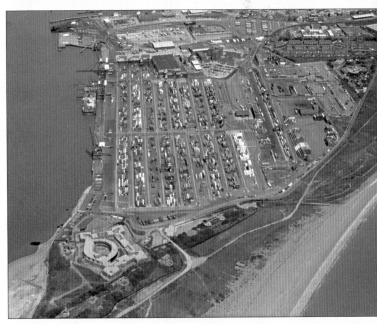

(NMR 21463/13 31-MAY-2002 © English Heritage.NMR)

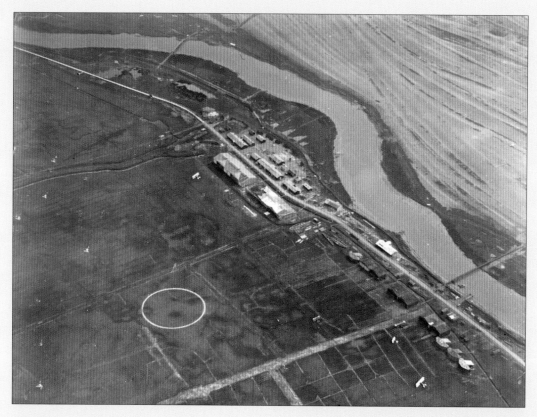

(The Hammond Collection)

Orfordness Experimental Station

The RFC's Experimental Flying Section arrived on Orfordness in the summer of 1915. Accommodation was basic, consisting of prefabricated wooden structures beside Stony Creek. The first hangars were aeroplane-shaped temporary canvas structures. These can be seen on Waldon Hammond's early aerial view of the base taken in 1915, with the permanent hangars visible at the top of the photograph (*above*).

To create a landing strip drainage ditches were filled in and uneven ground was levelled. Flooding on the site was countered by the construction of a new sea wall, most of the labour for which was provided by the Chinese Voluntary Labour Corps. This earthwork is still known as the Chinese Wall. The volunteers, mostly but not all Chinese, lived in accommodation to the north of the airbase, adjacent to a prisoner-of-war camp (*above, right*). The mainly German prisoners held there were employed in the maintenance of the base.

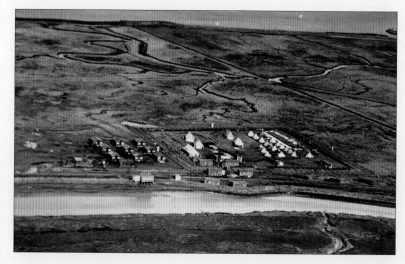

(The Hammond Collection)

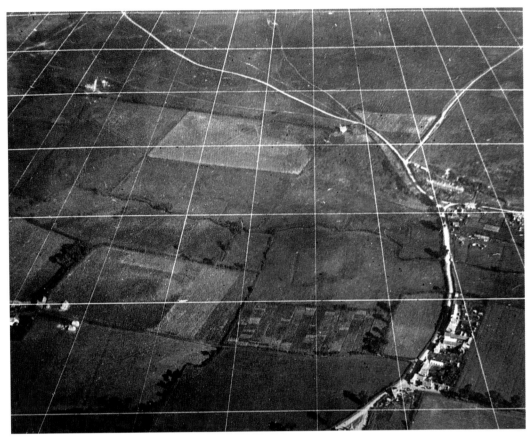

Fig 5.4 An oblique military reconnaissance photograph of Butley, taken by Waldon Hammond. The grid lines are Hammond's method of compensating for the oblique view. (The Hammond Collection)

Fig 5.5 Zeppelin L.48 was shot down over Theberton on the night of 16 June 1917 by pilots flying from Orfordness. (The Hammond Collection)

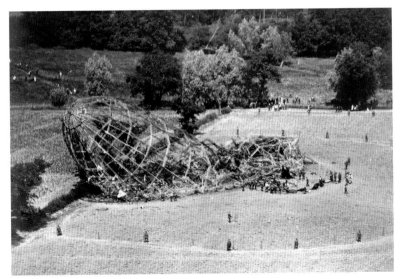

Aerial photography was at this time a new discipline, with limited numbers of photographs taken in comparison to the Second World War, so that few images are available for research. First World War coastal defences were less extensive and substantial than those of the Second World War, and consequently fewer features survived post-war demolition. Of those that survived, or have since become visible as cropmarks, the archaeologist can identify them from the air only if they have a shape that is distinct from later defences. Documentary evidence therefore plays a greater role in identifying the defences of the Great War.

The inter-war years

In the following two decades the absence of a strong enemy, the military preference for air defence over artillery, the economic privations of the Great Depression and the growth of the pacifist movement all combined to limit the development of military defences. Pragmatic plans were drawn up for defending cities and important ports with inland gun-belts and aircraft fighting zones, but other than maintaining a 'gun defence area' around the mouth of the Orwell and Stour rivers at Harwich Haven, the East Coast remained essentially undefended.

As the 1930s progressed it became clear that Hitler's Germany was the most likely enemy in any future war. This was soon reflected in national defence policy as an air-power arms race began, with the arguments of the 'bomber deterrent' movement increasingly dominating those of the advocates of anti-aircraft artillery. In a speech to the

House of Commons on 10 November 1932, Stanley Baldwin rather starkly summarised the prevalent view of anti-aircraft defence:

> I think it is well also for the man in the street to realise that there is no power on earth that can protect him from being bombed. Whatever people may tell him, the bomber will always get through ... The only defence is in offence, which means that you have to kill more women and children more quickly than the enemy if you want to save yourselves.
>
> (MacArthur 1999, 124–7)

Consequently coastal defence policy in general, and Suffolk's coastal defences in particular, remained largely unchanged until the outbreak of the Second World War.

Orfordness again

But Suffolk had other important roles to play. Developments in aeroplane technology since the First World War had emphasised the primacy of the air threat. Two sites on the Suffolk coast were to be particularly important in this field as Britain once more prepared for war. As aircraft range and speed increased, effective armaments and a reliable early warning system became vital.

Bombs away

The experimental base on Orfordness reopened in 1924, once more as a satellite to RAF Martlesham Heath, which was now the home of the Aeroplane and Armament Experimental Establishment (A&AEE). Despite reduced funding during the depression years, ballistics tests continued, with the area east of the Ness being used as a test range. Most drops were of 'dummies', to test the aerodynamics of new bombs and to give bomb crews the opportunity for simple practice runs. Some live bombs were also dropped, however, and the shingle was soon peppered with craters. Armaments tests and experiments continued throughout the war until the shingle to the east of the Ness came to resemble the surface of the moon.

Early warning's early days

The construction of an early warning system based on acoustic technology had been started at the end of the First World War, but was suspended as an alternative system emerged from an unlikely direction. In early 1935 the Air Ministry had asked a radiophysics research scientist, Robert Watson-Watt, to investigate the viability of

Orfordness: building better bombs

Orfordness was used for monitoring the viability of explosives stored elsewhere in the country. Some of the craters from explosives tests can be seen below (*top*), photographed from the air. In the 1930s the base expanded, new workshops and bomb stores were constructed, the staff complement was increased and specialised structures were built. Ballistics experiments were controlled from the Ballistics Building (*middle, i*), with bomb flights monitored by a timing beacon containing a complex array of cameras, mirrors and lights that was to become known as the Field of Mirrors (*middle, ii, and bottom*).

(Goldsworthy Collection)

(RAF 5/656 80 06-OCT-1941 English Heritage (NMR) RAF Photography)

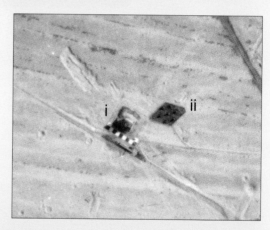

(Photograph: Ken Daykin/The National Trust)

anti-aircraft weapons based on radiation energy ('death rays'). Watson-Watt's team concluded that such weaponry was unrealistic, but realised that energy reflected from an aircraft might be used as a way of detecting it. A rapidly arranged and somewhat primitive test held in February of that year, using the BBC transmitter at Daventry, proved the basic premise to be correct.

To provide as few obstructions as possible a low-lying coastal location was needed for further research. By March 1935 Orfordness had been selected as the site of the first British research into Radio Direction Finding, soon to become known as radar (for radio detection and ranging). Watson-Watt and his small team moved from Slough to Orfordness in May 1935, renovating two First World War brick buildings for use as laboratories. Six masts over 20m high were built, two for the transmitter and two pairs of masts for receivers. The transmitter masts were soon replaced by even taller ones, 60m in height.

Early tests demonstrated that radar had potential but needed further development to provide the accurate early warning required for national defence. After just four months' work a larger project, to include the construction of a chain of radar stations, was approved. For that, expansion space was needed. By 1936 the research had moved 15km down the coast to Bawdsey Manor, and the construction of the first radar station had begun.

If Orfordness saw the birth of radar, Bawdsey Manor saw many sleepless nights before the technology matured. Nonetheless by 1937 the research had proved itself and, under the control of the RAF, Bawdsey took on an operational and training role. New radar stations were begun along the East Coast and by 1939 a system of 15 radar bases around the country, known as the Chain Home (CH) stations, were ready for operational use (*see* Chapter 6, Keeping an eye on the sky).

At the outbreak of the Second World War research staff left Bawdsey for safer locations, although development continued at the site. Without the work at Orfordness and Bawdsey the outcome of the Battle of Britain, and of the Second World War, might have been very different.

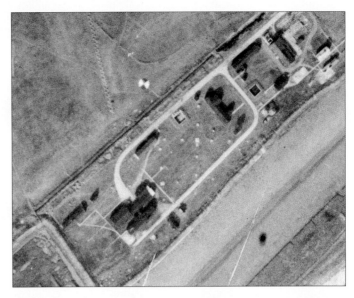

(RAF 106 GUK 929 4372ii 16-OCT-1945 English Heritage (NMR) RAF Photography)

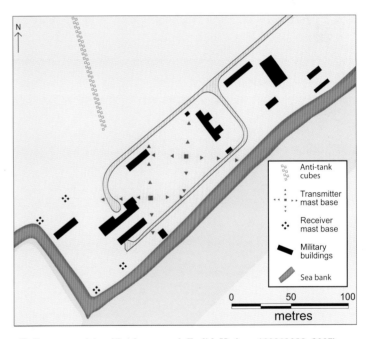

Orfordness and Bawdsey: from death rays to radar

The bases of Robert Watson-Watts' masts and the tethering points for the transmitter towers can be seen on aerial photographs of Orfordness taken in 1945 (*above*). Some of the tower bases survive today. The towers at Bawdsey Manor (*overleaf*) were even taller than those at Orfordness, taking full advantage of the elevation offered by Bawdsey's cliffs for greater range; receiver towers were nearly 75m tall, transmitters almost 110m. The pillboxes around the perimeter were constructed to protect the site from raiding parties.

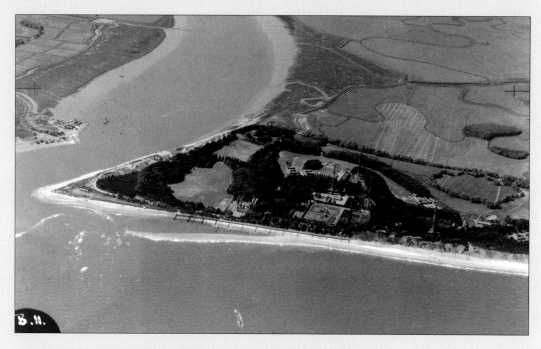

(MSO 31032/PO-2048 05-JUL-1940 English Heritage (NMR) RAF Photography)

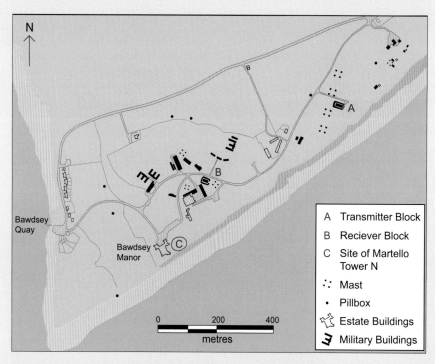

A	Transmitter Block
B	Reciever Block
C	Site of Martello Tower N
∴	Mast
•	Pillbox
✿	Estate Buildings
Ǝ	Military Buildings

N

Bawdsey Quay

Bawdsey Manor

0 200 400
metres

(© Crown copyright. All rights reserved. English Heritage 100019088. 2007)

6
The Second World War

During the Second World War RAF and US Army Air Force (USAAF) aircrew developed their aerial reconnaissance techniques over the East Anglian coast before commencing operations in Europe's hostile skies. Photographs taken during these flights record the rapid changes taking place in Suffolk's coastal wartime landscape. This chapter will illustrate how the military defences visible on aerial photographs reflect wider changes in strategy during the course of the conflict.

A state of war

On 1 September 1939 Germany launched an unprovoked attack on neighbouring Poland. With the Great War still painfully fresh in their memories, Poland's allies, Britain and France, were at first understandably reluctant to go to war. However, bound by treaty obligations, on the morning of 3 September British Prime Minister Neville Chamberlain made his now infamous radio broadcast:

> This morning the British Ambassador in Berlin handed the German Government a final note stating that, unless we hear from them by 11 o'clock that they were prepared at once to withdraw their troops from Poland, a state of war would exist between us. I have to tell you now that no such undertaking has been received, and that consequently this country is at war with Germany.

An air-raid siren sounded in London almost immediately after the announcement, echoed later that evening in Southwold on the Suffolk coast. But while London enjoyed the protection of Heavy Anti-Aircraft Artillery batteries, no such defences were in place at Southwold, nor along much of the Suffolk coast. As the British Expeditionary Force joined its allies in France, the wail of that siren was Suffolk's only real sign of war. As the conflict in Europe entered a nine-month phase of inactivity which came to be known as the Phoney War, British Home Forces raced to enhance anti-aircraft defences in preparation for a feared *blitzkrieg* (lightning war) of the type that had so utterly crushed Poland.

This uncertain calm did not last. In April 1940 the *blitzkrieg* struck at Norway and Denmark and a month later at Holland and Belgium. French and British forces came to Belgium's aid but the German *Wehrmacht* (armed forces) outmanoeuvred the poorly coordinated Allies by unexpectedly striking into France through the Ardennes. This caused chaos and ultimately the withdrawal of the British Expeditionary Force and 100,000 French troops from Dunkirk. France could not resist the German Army alone and, following the fall of Paris, signed an armistice with the invaders on 22 June 1940.

For the first time since 1918, an invasion of Britain was a real possibility. From the outset, however, the greatest threat was to come not from the sea, but from the sky.

Fire in the sky

By the mid-1930s Britain's preference for maintaining a bomber deterrent over other forms of air defence had limited the development of anti-aircraft artillery. Germany had a vast number of new bombers at its disposal, with a greater speed, range and payload than those faced during the Great War. Growing fears of an attempted German 'knock-out blow' against Britain prompted the Minister for the Coordination of Defence to reassess defensive strategies. Acknowledging for the first time the bomber deterrent's limitations, he called for an integrated system of defences to be planned, including strategically located anti-aircraft artillery alongside searchlights and barrage balloons.

As the threat grew and war seemed increasingly likely, anti-aircraft artillery protection concentrated on the defence of London. When the war began this protection was extended to important ports and naval anchorages. In Suffolk, this increased defence capability enhanced the existing Gun Defence Areas around Harwich and Lowestoft (Fig 6.1).

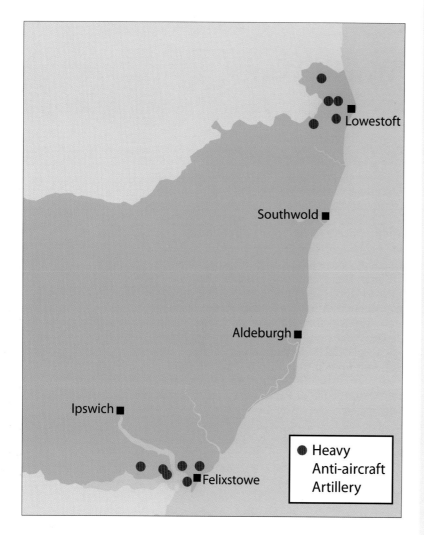

Fig 6.1 Heavy Anti-aircraft Artillery batteries on Suffolk's coast. (© Crown copyright. All rights reserved. English Heritage 100019088. 2007)

Suffolk's anti-aircraft batteries

The layout of a Heavy Anti-aircraft Artillery (HAA) battery at Felixstowe is characteristic of sites constructed just before and during the early years of the Second World War (*opposite*). A typical wartime HAA battery camp, auxiliary buildings and gun-laying radar platform can be seen at Lound in 1945 (*p 38, top and bottom*). Most huts and other semi-permanent structures were removed from HAA batteries by 1946. Once the land was returned to its original use, the camps often left little trace. Some of the substantial concrete gun emplacements, however, survived for many years as reminders of the bomber threat (*see* Chapter 8).

The rise of anti-aircraft artillery

Military strategists expected bombing accuracy to have improved since the Great War. Attacks on strategically important sites were therefore anticipated in the forthcoming conflict. For this reason new anti-aircraft batteries were built close to potential targets, for example those at Felixstowe which were in place by February 1940. Such early Heavy Anti-aircraft Artillery (HAA) batteries can be identified from their distinctive plan, based on a design issued by the Directorate of Fortifications and Works in 1938. This template was still in use in the early war years, and the batteries at Felixstowe were probably based upon local adaptations of it.

Felixstowe's early HAA batteries used concrete-walled, earthwork-revetted, octagonal gun emplacements ('gun pits') within which 4.5-inch or 3.7-inch guns were bolted to a central holdfast. The standard

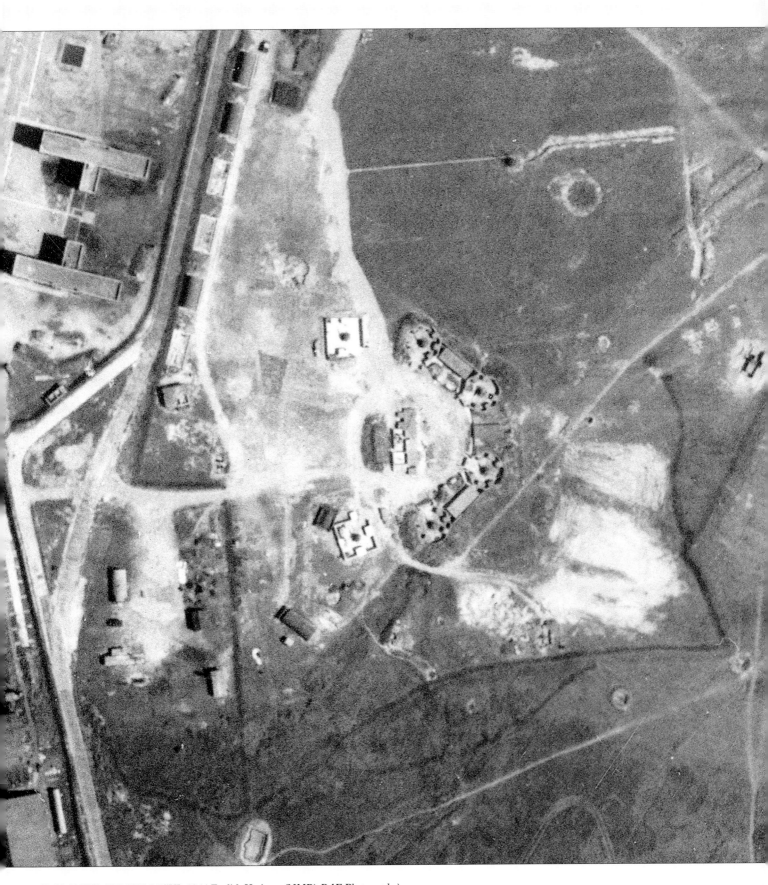

(RAF 106G/LA/22 4010 06-JUL-1944 English Heritage (NMR) RAF Photography)

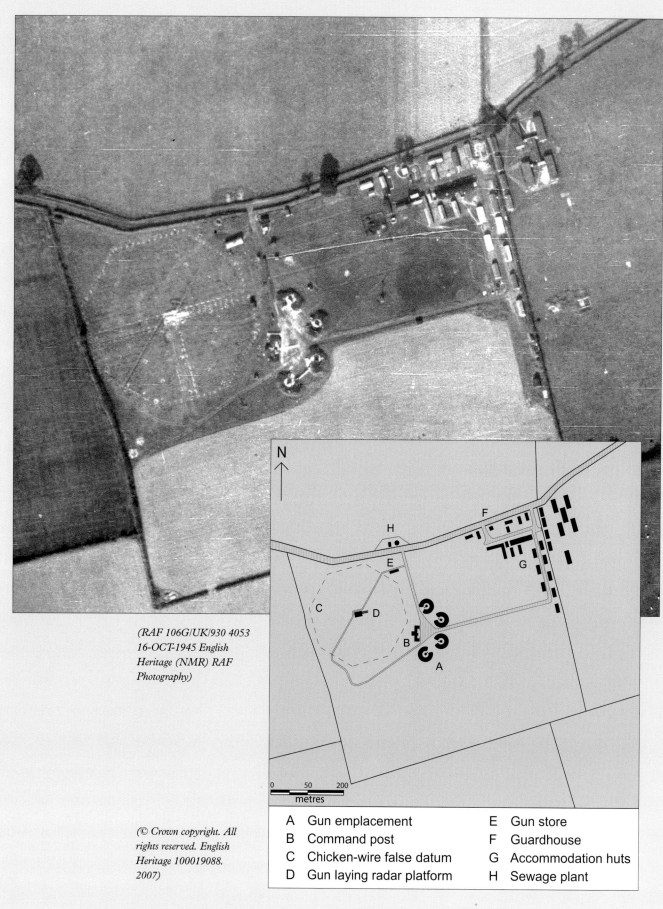

(RAF 106G/UK/930 4053 16-OCT-1945 English Heritage (NMR) RAF Photography)

A	Gun emplacement	E	Gun store
B	Command post	F	Guardhouse
C	Chicken-wire false datum	G	Accommodation huts
D	Gun laying radar platform	H	Sewage plant

battery had four emplacements, with two intended for actual use and two to reduce the need for later construction. The outermost emplacements were set back from the central pair to curve around the central structures housing the battery's command post. Within the command post, the plotting and communication rooms were protected by a concrete roof but the instruments vital to the guns' performance, such as an identification telescope, predictor (an early form of mechanical computer) and height finder, were open to the sky.

Before the war anti-aircraft guns had been manned by Territorial troops, billeted nearby. After Anti-Aircraft (AA) Command was created in April 1939, the ranks of gun crews swelled with regular troops. At many batteries these troops were housed in new hutted camps, usually built along the battery access road.

The bombing raids of 1940, known as the 'Blitz', were AA Command's first great challenge. Largely targeting inland towns and cities, the impact of the Blitz on Suffolk's coast was limited. However, from the spring of 1942 the Luftwaffe began its so-called 'Fringe Target Raids', a new campaign of attacks on undefended coastal towns. AA Command responded by redeploying anti-aircraft batteries to selected coastal towns. Documentary sources say that by June 1942 Lowestoft and Felixstowe were the only Suffolk towns to have received additional batteries, with Lowestoft getting three and Felixstowe two. However, most of these cannot be seen on aerial photographs and it is likely that they were either short-lived or possibly never built.

In the early spring of 1942 one of the war's more unusual forms of anti-aircraft artillery was installed off the Suffolk coast, at Roughs on the Essex border. The naval sea fort, designed by engineer Guy Maunsell, was an offshore stronghold housing radar, anti-aircraft guns and some 100 personnel. The one at Roughs, consisting of two 60 ft (about 18m) cylindrical towers which sat mostly submerged, with a large rectangular platform on top, was constructed at Gravesend, towed into position and sunk seven miles (about 11km) off Harwich. This was the most northerly of four sea forts meant to plug a gap in East Coast defences, installed across the Thames Estuary and Harwich Haven approaches to prevent enemy aircraft laying mines in these areas. The army also built on-shore sea forts in the Thames Estuary itself.

Despite the redeployment of anti-aircraft guns and the construction of the sea forts, coastal air attacks continued. Aldeburgh suffered its most terrifying attack of the war on 15 December 1942, when a Dornier 217 dropped four 500kg bombs on the town, devastating buildings and killing or injuring 40 people. Only in the final year of the war did the Suffolk coast see a significant increase in the number of anti-aircraft guns. This was in response to strategic considerations very different to those earlier in the war and which, as we will see later in this chapter, would prove to be AA Command's second great challenge.

Early warning, deterrents and decoys

Anti-aircraft guns were not the only defence against airborne threats. Work continued on the development of a national chain of radar stations which had begun with the experimental systems at Bawdsey and Orfordness (*see* Chapter 5). A variety of novel anti-aircraft defences were also developed that complemented the protection provided by radar and anti-aircraft artillery. These took a variety of forms but displayed a unity of purpose in preventing enemy aircraft from reaching their intended targets.

Keeping an eye on the sky

By the time the war began in September 1939, a national chain of radar stations was under development. In Suffolk, in addition to the original experimental station at Bawdsey, another receiver block was in place at High Street, 7km inland. These first radar sites, known as Chain Home (CH) sites (or East Coast Chain Home in the case of the Suffolk sites), comprised four steel transmitter masts arranged in a row with an embanked transmitter block, and four wooden receiver masts arranged around an embanked receiver block, as in the layout at Bawdsey (*see* p 33). In addition a stand-by generator and other auxiliary buildings were located at these sites. When war broke out sites were also provided with anti-invasion defences to protect against ground attack.

In July 1939, just before war broke out, army research into Coastal Defence radar (CD) demonstrated that this new technique could not only detect shipping movements and shell explosions but also low-flying aircraft, an area where the CH network was

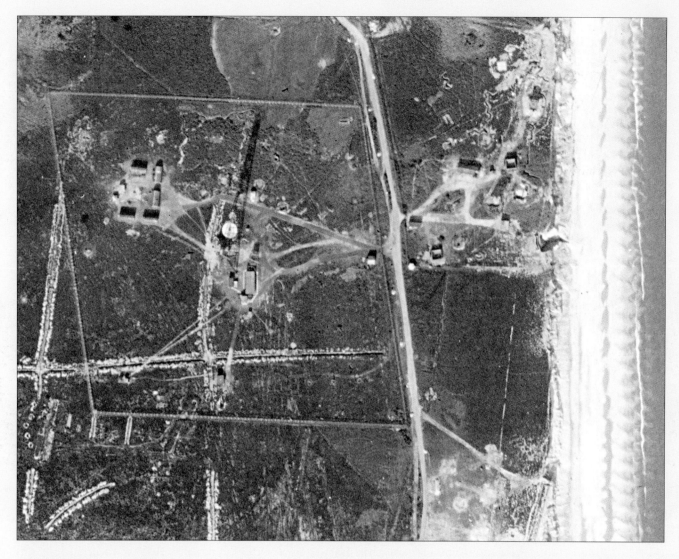

Chain Home Low radar site

The original system of Chain Home (CH) radar stations underwent modifications throughout the war, including the development of Chain Home Low (CHL) stations like this one at Dunwich, pictured in 1945. This station, originally an army anti-aircraft radar site, was one of the first CHL sites to be developed, opening on 1 January 1940 for the protection of Harwich. Because of their more focused signals, CHL sites could be much smaller than CH sites. The Dunwich site was surrounded by an anti-tank cube enclosure, and a number of small buildings are visible along with the 184ft (56m) aerial which casts a dark shadow across the northern part of the enclosure. Other anti-invasion defences are also visible, including anti-glider ditches (discussed later in the chapter) running into the anti-tank cube enclosure.

(RAF 106G/UK/929 4166 16-OCT-1945 English Heritage (NMR) RAF Photography)

weak. By the spring of 1940 this system was known as Chain Home Low (CHL) and was used in combination with other CH stations for just this purpose. On the Suffolk coast CHL stations were sited at Dunwich (*see* opposite page) and subsequently at Bawdsey, Hopton and Thorpeness. These first CHL stations were sited on the East Coast to protect ports from mine-laying aircraft, but the chain was later extended to cover other stretches of Britain's coast. In addition many CD radar sites, initially run by the army until the programmes were merged, were turned into combined CD and CHL sites, as at Aldeburgh.

The combination of CH and CHL radar stations gave British fighters a fundamental advantage in the Battle of Britain air war which took place between July and October 1940. Though crude by today's standards, it gave RAF Fighter Command information about the bearing, range and size of incoming raids. The system was so effective that it forced German bombers to move to night raids towards the end of 1940. This caused problems for the CH/CHL system, which only gave general positions for incoming aircraft, forcing fighters to rely on visual sightings. The fact that there was no inland radar cover (the CH and CHL systems being focused on the coast) was also proving to be a problem.

A new radar system was therefore developed, called Ground Controlled Interception (GCI). This worked in combination with equipment fitted in the fighters themselves to accurately guide them to raiding bombers during the hours of darkness. The system, much more complex than the CH/CHL system, was developed in several stages between late 1940 and 1942 (*see* right). Chain Home Extra Low (CHEL) systems, which gave much more accurate sea-level coverage, were also being developed, and were to become the standard type of radar station by the end of the Second World War.

Another type of radar, Fighter Direction, developed during the later years of the war could detect German fighters over Europe with a range of up to 200 miles (about 320km) and direct Allied planes to them. One of the first of these installations, known as a Type 16 Fighter Direction Station, was established on the Suffolk coast at Greyfriars, near Dunwich, in May 1943.

Because of the county's proximity to mainland Europe, early warning continued as an important aspect of the military presence on the Suffolk coast after the war, as discussed in Chapter 7.

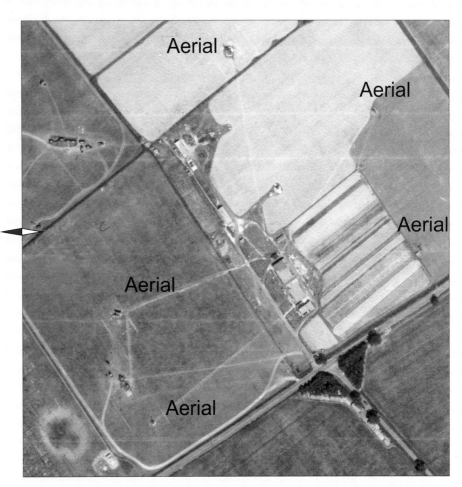

(RAF 106G/LA/23 4026 06-JUL-1944 English Heritage (NMR) RAF Photography)

Ground Controlled Interception

The Ground Controlled Interception (GCI) station at Trimley Heath, north-west of Felixstowe, was among a number of such stations developed on the Suffolk Coast. The site, seen here in July 1944, was a 'Final GCI' station, meaning that it was more advanced than other GCI stations, and capable of controlling the interception of several different aircraft simultaneously. The positions of several aerials, as well as the operations block and other auxiliary buildings, can clearly been seen.

Fig 6.2 A barrage balloon moored at Felixstowe. (Photograph courtesy of Neil Wylie, John Smith, Peter White and Phil Hadwen)

Deterrents

During the First World War large balloons had proved so effective in preventing German Gotha bombers from flying low over London that Balloon Command was formed in the build-up to the Second World War. Balloons were tethered at vulnerable locations to form barriers known as barrages. Varying the number and height of these 'barrage balloons' forced enemy bombers to increase altitude, reducing their bombing accuracy and forcing them into the range of anti-aircraft artillery. The balloon cables themselves were also an effective obstruction, damaging any aircraft that struck them. They later proved to be an effective obstacle to the V1 flying bombs as well; over 200 of the missiles were destroyed by the balloons.

The balloons were enormous, nearly 20m long and 10m high (Fig 6.2). Early in the war most were set up around London, although some were established at vulnerable areas on the Suffolk coast. Barrage balloons could be mobile, attached to lorries or ships, or tethered to a particular spot, making them suitable for protecting a range of sites. Although mainly used at military installations in Suffolk, they also protected some towns and ports.

Aerial photographs suggest that most balloons were relatively late arrivals, probably between 1942 and 1944, on Suffolk's coast. Most appear to have gone out of use before the end of the war, but the tethering rings of permanent balloon sites and their associated buildings remain clearly visible on aerial photographs.

Suffolk's barrage balloons proved effective at deterring bombing raids at key targets, occasionally to the detriment of neighbouring towns. In May 1943 the balloons of Landguard and Shotley deterred German bombers who instead discharged their payload on the undefended hamlets of Felixstowe Ferry and Southwold, killing ten people and wounding six.

Decoys

A completely new approach to air defence was developed just before the war. 'Decoys' were built to fool enemy bombers into attacking artificial sites rather than their true targets. The earliest examples consisted of dummy airfields complete with full-size imitation aircraft for daylight raids and fake flare-lit runways for night raids. Such decoys were built for some of Suffolk's numerous airfields but none were located along Suffolk's vulnerable coastal strip. These decoy airfields were called Q sites, from the name given by the Royal Navy to warships disguised as merchant vessels.

As the war progressed and night raiding became widespread, decoy sites became more sophisticated. It was observed that the flames of bombed airfield decoys attracted more bombers. This inspired the development of decoys which mimicked the fires of bombed airfields. Following the devastation of Coventry in November 1940, this idea was expanded further into large decoys which simulated the extensive fires of a city ablaze.

The 'Q' prefix continued in use with later decoys, for example the Q Light (QL) decoys which used electricity to replicate the lights of potential urban or industrial targets, such as the sparking of trams or the glow of furnaces or steam-train fireboxes. Variety in colour and intensity of lighting was essential to produce convincing results. Once enemy bombers had been lured away from their real objective, another type of decoy used fire to create the impression of a burning target. These were called Special Fire (SF) sites, later changed to the codename Starfish. To be as convincing as possible, Starfish sites used a variety of fuels such as paraffin, diesel or coal to produce coloured flames and explosions. Interspersed amongst these were wood-chip and creosote fires in large baskets, to provide a steady blaze. QL and SF sites were often built together to provide the most convincing decoy.

Most 'urban' decoys were concentrated around the vulnerable industrial centres of the West Midlands and the North. Ipswich was the only settlement to warrant large decoys in Suffolk.

It is often difficult to be certain whether a decoy site was successful. During the war Starfish sites were only recorded as having drawn attacks if bombs fell within three-quarters of a mile (1.2km) of them. These rigorous standards were adhered to despite the Air Warfare Analysis section having proved that bombs frequently fell up to two miles (about 3.2km) from their intended targets. Nonetheless the value of the Ipswich decoys appear to have been proven on the night of 1 June 1942, when the bombs of a raid fell on the surrounding countryside and not the town itself.

The dawn of civil defence

Prior to the Second World War, civil defence provision had been limited. The Air Raid Precautions (ARP) Department of the Home Office, formed in 1935, had produced limited guidance for the defence of homes against gas attack and air raids. Construction of air-raid shelters was at first voluntary, a matter for the individual, until 1938 legislation made public shelters the responsibility of local authorities. Public shelters were for those caught outside during a raid and were not intended, as many thought, as communal shelters for the whole populace. Even so, these measures were slow to be implemented until the Munich Crisis of the same year, when it appeared that Britain might be drawn into war over Hitler's annexation of the Sudetenland. This crisis, heightening fears of aerial bombardment, provided the first real impetus for the provision of civil defence.

From Munich trenches to public shelters

The government felt the populace would be safer in numerous small 'dispersed' shelters rather than in a few large ones. Small shelters would also be cheaper to build. Consequently the Munich Crisis led to the digging of many simple shelters – some little more than trenches – in back gardens, parks and school grounds. These 'Munich trenches' varied in size from small family shelters to larger ones for schools and workplaces. Quickly dug, most of them deteriorated over the winter of 1938–9 and were either abandoned or filled in. After war was declared, many were hurriedly repaired and often continued in use throughout the war.

After the Munich Crisis highlighted the poor provision of air-raid shelters, Sir John Anderson was appointed as minister to coordinate the ARP effort. He implemented many civil defence measures, the most famous being the iconic air-raid shelter that bore his name. Free to low-income families, and for sale to others who wished to buy it, this simple shelter was designed to provide

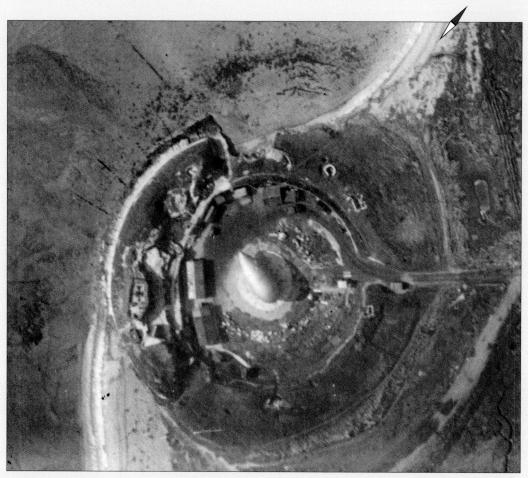

*(RAF HLA/698 3089
08-APR-1944 English
Heritage (NMR) RAF
Photography)*

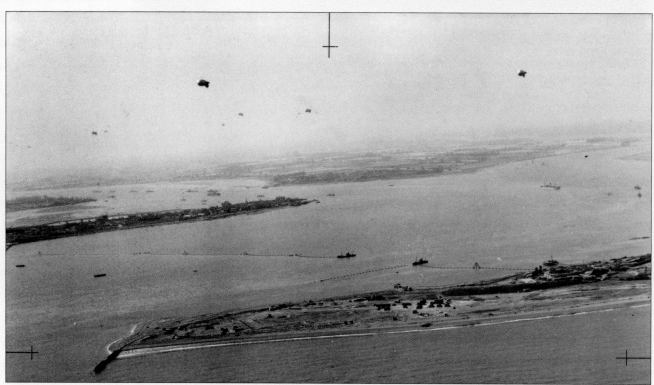

(MSO 31219/po-28 TM2831/40 23-JUL-1941 English Heritage (NMR) RAF Photography)

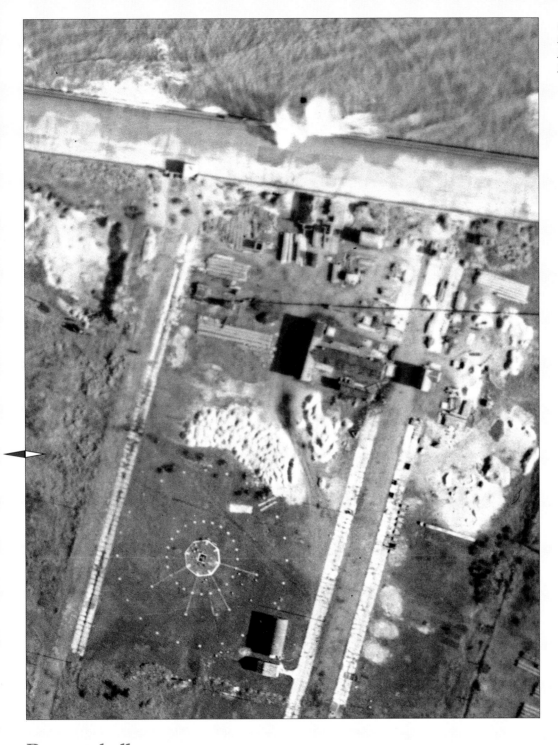

*(RAF 106G/UK/1146
5031 30-JAN-1946
English Heritage (NMR)
RAF Photography)*

Barrage balloons

Most barrage balloons on the Suffolk coast were moored at military targets. Multiple mooring sites were established around Harwich Haven, for example. The barrage balloon (*opposite, top*) moored on the site of the demolished Martello Tower N at Walton Ferry, near Felixstowe, and photographed in 1944, is a reminder of the area's strategic importance. Balloons were also moored to ships in the River Orwell estuary to deny mine-laying aircraft access to the river (*opposite, bottom*). Balloons were only used at Suffolk's second port, Lowestoft, after it suffered repeated air raids, narrowly avoiding devastation in October 1943. A mooring site at Lowestoft is visible in this 1946 photograph (*above*).

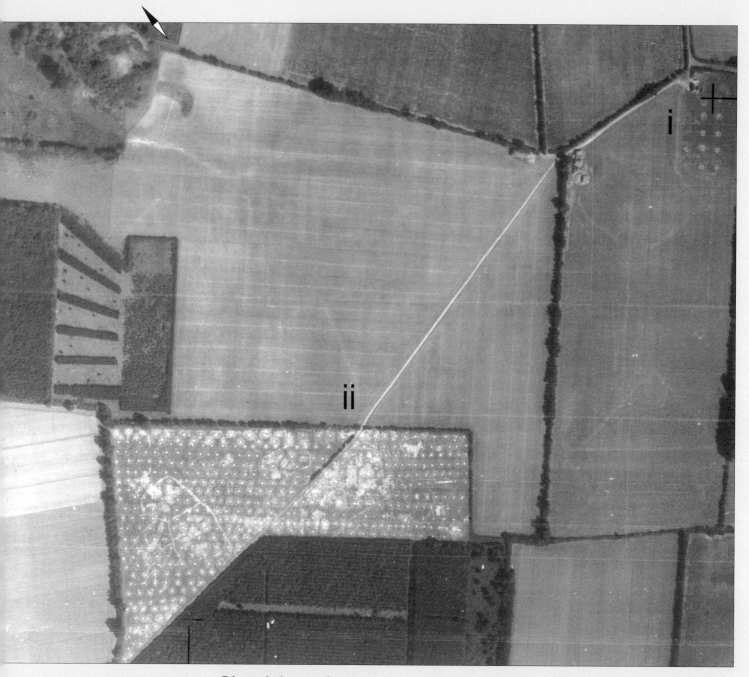

(RAF 106G/UK/759 2034 02-SEP-1945 English Heritage (NMR) RAF Photography)

Shottisham decoy

The paired arrangement of QL (*i*) and SF (*ii*) decoys can be seen in 1945 at Shottisham (*above*), one of a number of decoy sites built to protect Ipswich, about 15km to the north-west. The Shottisham QL site probably replicated the effect of city lights leaking as a result of poor blackout measures, and 'permitted lighting' such as the glow of factories and marshalling yards. Safety was understandably important at SF decoys, and the fires were enclosed by firebreak trenches, more clearly visible at the nearby Bucklesham decoy, photographed in 1944 (*opposite*).

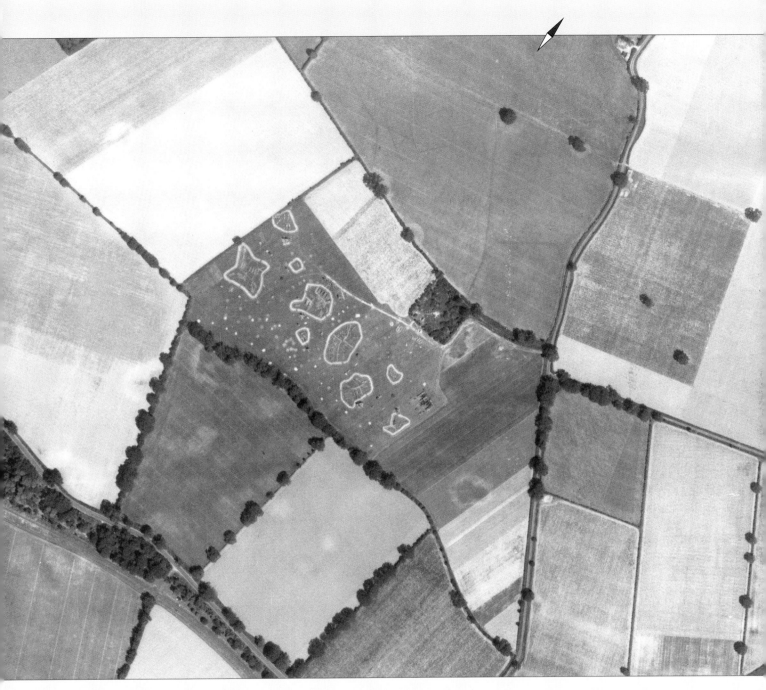

(RAF 106G/LA/22 4060 06-JUL-1944 English Heritage (NMR) RAF Photography)

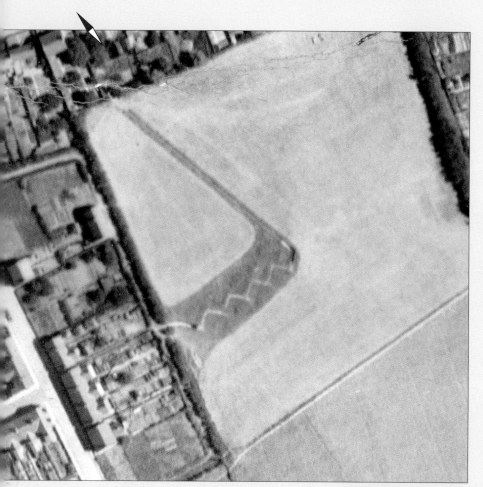

Trench shelters

A zigzag-shaped public trench shelter is visible in a field behind houses in Walton, Felixstowe, in 1944 (*left*). A smaller, V-shaped domestic 'garden trench' can be seen in the back garden of a house in the same area (*below, left*). Some trench shelters were consolidated and covered with concrete and steel lining, providing communal shelter for several hundred people. At Shotley, overlooking the strategically important anchorage of Harwich Haven, an extensive trench shelter complex almost 600m in length was constructed, probably to serve local residents and naval recruits training at the nearby base of HMS Ganges. In 1944 this was visible only as a cropmark, its true nature only revealed in 1946 when it was uncovered and filled in (*opposite, top and bottom*).

(RAF 106G/LA/34 4072 15-AUG-1944 English Heritage (NMR) RAF Photography)

(RAF 2B/BR168 1 18-DEC-1941 English Heritage (NMR) RAF Photography)

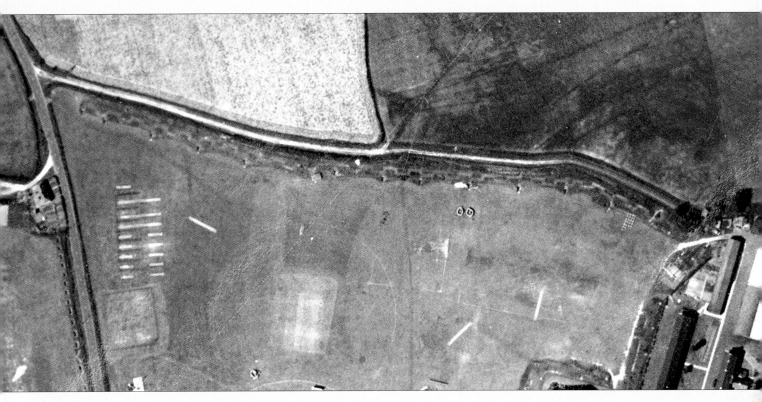

(RAF 106G/LA/23 4022 06-JUL-1944 English Heritage (NMR) RAF Photography)

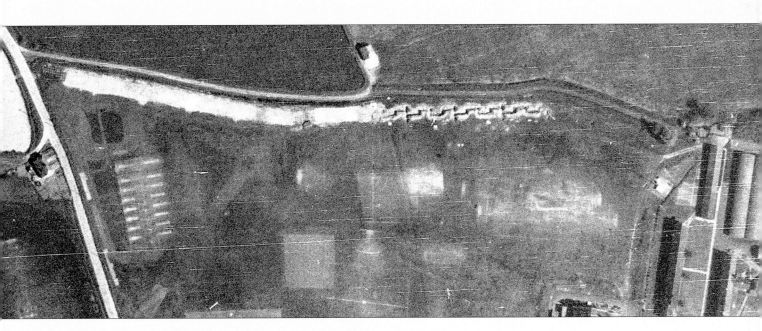

(RAF 106G/UK/1492 3074 10-MAY-1946 English Heritage (NMR) RAF Photography)

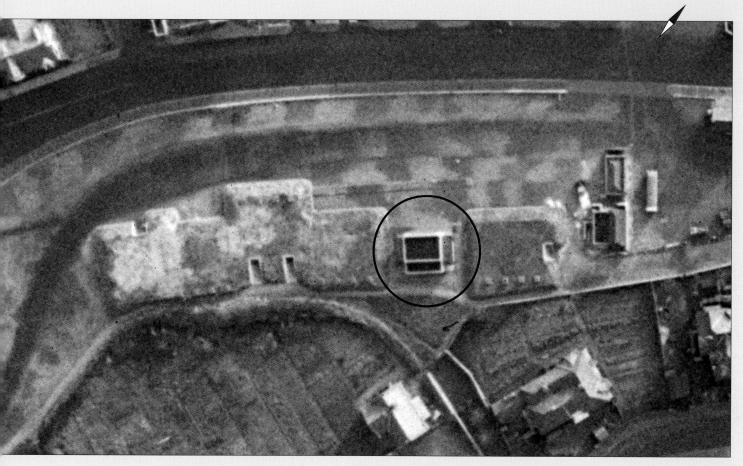

(RAF 2H/BR165 19 24-DEC-1941 English Heritage (NMR) RAF Photography)

Public and private shelters

A possible early public surface shelter, between two trench shelters on Battery Green Road in Lowestoft, is seen here in 1944 (*above*). This was the first type of purpose-built, above-ground public shelter. Standard designs accommodated up to 50 people.

A covered trench shelter shared between the gardens of two seafront houses in Lowestoft is visible on a 1944 aerial photograph (*right*). This shelter may indicate private investment in protection from the increased bombing threat of the Fringe Target Raids. In contrast, communal public shelters can be seen scattered around the urban housing estates of Felixstowe and Lowestoft (*opposite page*).

(RAF HLA/698 4009 08-APR-1944 English Heritage (NMR) RAF Photography)

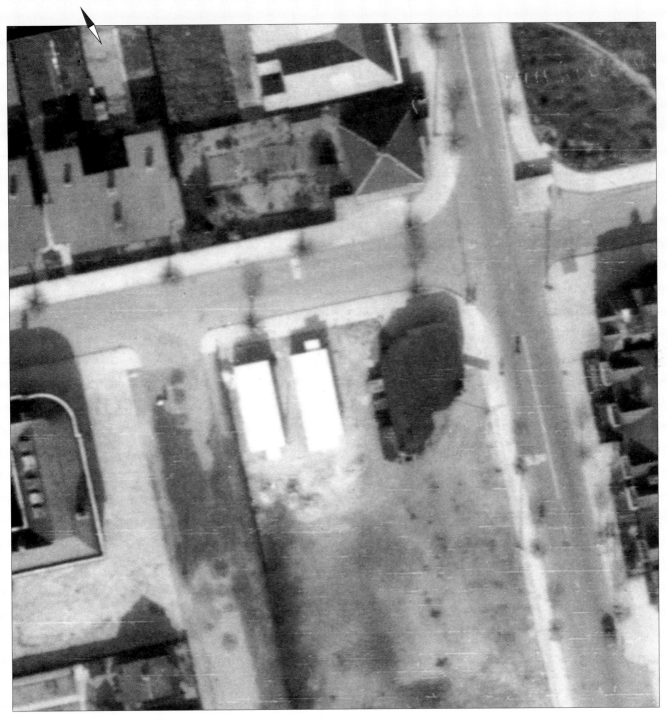

(RAF HLA/698 4087 08-APR-1944 English Heritage (NMR) RAF Photography)

some protection by being partly buried in a garden. Domestic surface shelters of brick with flat concrete roofs were soon developed as alternatives for areas without gardens. Uptake of domestic shelters was initially slow throughout Britain, but as war approached, demand increased.

As the domestic Anderson shelters were launched and the Blitz began to devastate London, designs were also issued for public shelters. Similar in construction to the brick-built domestic shelter, the standard designs were often adapted by local authorities, architects and building firms. As with the coastal anti-invasion defences, local adaptations appear to have been built in Suffolk (*see previous page*).

A lull in concentrated bombing followed the Blitz, and many shelters went unused for a time. However, during the two years following 1942, Suffolk suffered the so-called Baedecker raids and the Fringe Target Raids, its most brutal air attacks. Although these were sporadic and unpredictable, and public civil defence requirements were not easily anticipated, from this time until the end of the war growing numbers of air-raid shelters, domestic and public, are visible on aerial photographs. This probably reflects the increased vulnerability felt by Suffolk's coastal population, culminating with the onslaught of the V-weapons in 1944, for which shelters provided the only possible, if limited, protection. With the return of night raiding, families spent considerable time in their shelters, often sleeping in them overnight.

The construction of substantial shelters is an understandable reaction in those able to afford their own protection. For those who could not build such structures at home, communal domestic shelters became increasingly important. These quickly accessible shelters would have complemented existing domestic ones, and public shelters became an everyday part of the urban wartime experience.

There are some limitations to the use of aerial photographs for identifying civil defence precautions. Firstly, not all shelters were built outside. Many people preferred to stay indoors, using government-issue kits to 'bombproof' rooms, or to employ a Morrison shelter, basically a reinforced table containing a mattress. Industry and large companies were required to provide their employees with on-site shelter, often within their premises. In addition, Suffolk's coastal settlements did not suffer to the same degree as larger inland towns and cities; indeed in the first months of war Suffolk was seen as a safe haven for evacuees, and it is therefore possible that only limited numbers of domestic shelters were built. Finally, even shelters built in gardens or parks may be hidden by vegetation from the eyes of the photograph interpreters. Much has been written about the Blitz and the experiences of Britain's urban population, but the national distribution of wartime air-raid shelters remains unknown. The aerial photographs of Suffolk's coast nevertheless provide an insight into how ordinary people in this corner of the country may have faced the spectre of the bomb.

The coastal crust

Following the fall of France in June 1940, Hitler prepared for an invasion of Britain, codenamed Operation Sealion. In advance of this invasion Hitler ordered the Luftwaffe to eliminate the RAF, which resulted in the air battle now known as the Battle of Britain. With the aid of radar the RAF's fighter pilots – Churchill's 'few' – held the Luftwaffe at bay. As German bombers subsequently switched their attacks from RAF airfields to cities, the Battle of Britain became the Blitz . It is now recognised that the start of the Blitz marked the end of the invasion threat, but at the time these events sent shockwaves through British national defence planning.

A number of individuals controlled home defence throughout the war, each commander viewing defence needs differently. In June 1940 General Ironside replaced General Kirke as Commander-in-Chief of Home Forces, only to be replaced himself in July by General Brooke. As will be seen below, the development of coastal defences in Suffolk reflected the strategies of each commander.

Suffolk was in Eastern Command. It reflected the perceived vulnerability of the East Anglian coast that Eastern Command was the first to complete construction of its coastal defences. This process was captured in incredible detail on aerial photographs taken during training flights in 1940–41. These photographs provide a unique perspective on the impact of the short-lived defences on Suffolk's coastal landscape.

Coastal Emergency Batteries

If, in 1939 or early 1940, an invading fleet had breached air and naval defences, they would have found much of Britain's coastline poorly protected. Coastal batteries were located at Landguard Fort and Lowestoft but, at the outbreak of war, much of Suffolk's coast was defenceless.

The first major shift in coastal defence strategy followed the fall of Holland in May 1940. When the Chiefs of Staff realised the Royal Navy could not guarantee against enemy landings, artillery protection was expanded beyond the ports using newly available surplus naval guns. Emergency Coastal Batteries – such as the Gunton Cliff, South Pier, Grand Hotel and Pakefield batteries at Lowestoft – were established at coastal towns and at regular intervals along isolated stretches of coast.

That protecting Suffolk's coast was a high priority is reflected in the fact that the Emergency Battery at Aldeburgh was among the first to become operational, on 6 June 1940. At first this was a makeshift structure of sandbags and girders, partially enclosing two temporary platforms housing surplus naval six-inch guns. By September 1941 these had been replaced by more permanent structures, with concrete roofs providing protection for the gun crews and permanent ammunition stores connecting the two guns, roughly 50m apart.

Emergency Batteries often adapted their design and layout to local circumstances, incorporating existing structures. At Aldeburgh a 19th-century pump windmill was converted into a battery observation post (Fig 6.3). This was both economical and provided good camouflage.

By 1941, 76 coastal Emergency Batteries had been built in Eastern Command, 13 of them on the Suffolk coast. Few records exist for these often unique emergency defences, and few batteries survive. Aerial photographs provide a rare and valuable record of their role in wider coastal defence.

Fig 6.3 Aldeburgh coastal battery observation post. (Suffolk Record Office, Ipswich branch K681/1/3/128)

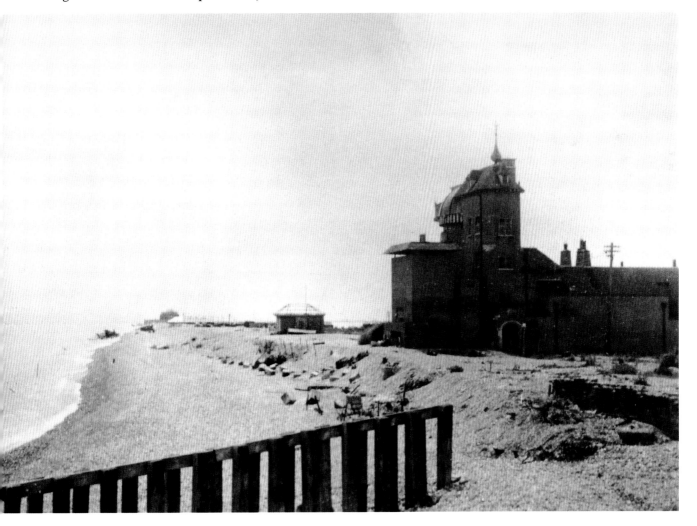

Aldeburgh Emergency Battery

The temporary gun houses of Aldeburgh's Emergency Battery can be seen on this 1940 aerial photograph (*right*). During construction of the permanent battery in 1941, the southernmost gun ('Gun One') was adjusted to aim 45 degrees to the south of the other to provide a wider field of fire (*opposite, left and right*). Two Coastal Artillery Searchlights (CASL) are also visible on the seafront, and an engine room and other auxiliary buildings are to the rear. No temporary accommodation can be seen on the aerial photographs; it is likely that gun crews were billeted in the town or even in the neighbouring Brudenall Hotel. The battery was flanked by anti-invasion strongpoints and pillboxes to the north and south, forming an integrated coastal defensive system. Few elements of Aldeburgh's battery survive today, other than the gun house of 'Gun One', which has been converted into a beachfront shelter.

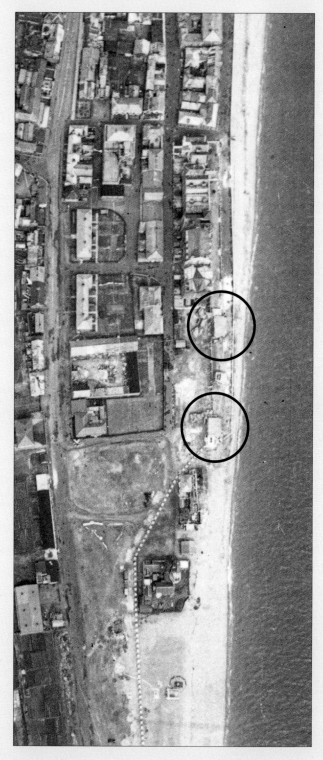

(*RAF 2A/BR11/14 2 08-JUL-1940 English Heritage (NMR) RAF Photography*)

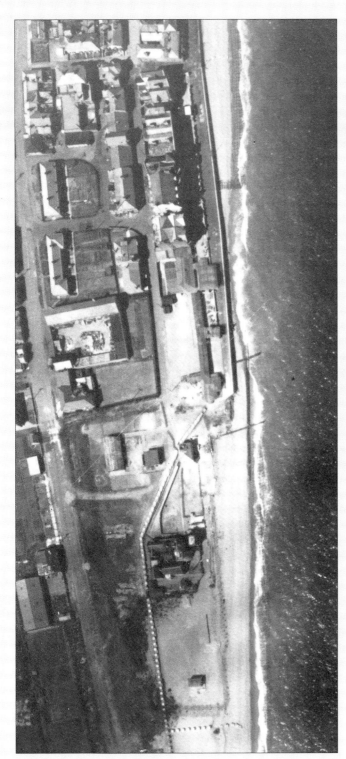

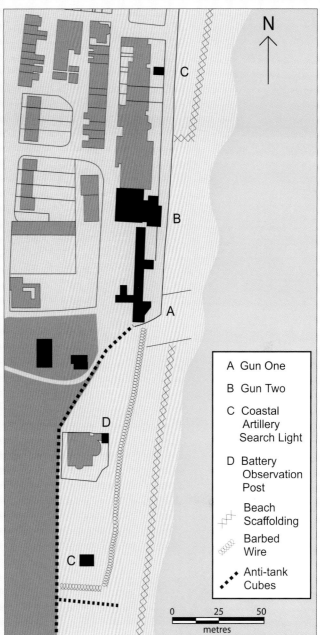

A Gun One

B Gun Two

C Coastal
 Artillery
 Search Light

D Battery
 Observation
 Post

 Beach
 Scaffolding

 Barbed
 Wire

 Anti-tank
 Cubes

N

0 25 50
metres

Coastal anti-invasion defences

When General Ironside replaced General Kirke as Commander-in-Chief of Home Forces in June 1940 his response to the invasion threat was to order the building of a series of inland stop-lines and a 'coastal crust' of anti-invasion defences along Britain's vulnerable shores. This crust was composed of obstructions and manned pillboxes intended to slow enemy forces, particularly tanks, providing time for a mobile reserve force to retaliate. Many pillboxes were disguised, either with earth and vegetation, or in more urban areas with novel decoration and modifications.

Many of Suffolk's surviving wartime coastal defences originated from General Ironside's scheme. However, his ideas were criticised by some for being entrenched in the mentality of the First World War, particularly by General Brooke who replaced him in July. Brooke felt that pillboxes isolated troops and that stop-lines were too long to be defended with the limited manpower available. This may have been true, but it is possible that Ironside was simply making the best of the limited resources available.

Constructing the coastal defences was a logistical and engineering feat, requiring massive amounts of raw material and labour, much of it supplied by local companies such as Garretts of Leiston. However, for a number of reasons the evolution of these defences is poorly understood. Many were short-lived or changed dramatically throughout the war. Military records do exist for anti-invasion defences but are less comprehensive than for other Second World War site types. Ultimately their sheer number makes this a subject difficult to research and disseminate. It is fortunate that the expansion of anti-invasion defences along the Suffolk coast was recorded on aerial photographs taken by the RAF from the summer of 1940 onwards, and in the later years of the war by the USAAF.

Suffolk's crust

Suffolk's coastal defences reflected constraints imposed by the landscape as well as by military priorities. In 1940 General Headquarters issued directives that ditches were the best anti-tank obstacles. By the end of 1941 many kilometres of these had been excavated, or drainage ditches widened to form effective barriers as was the case in the county's low-lying and largely reclaimed coastal fringe (*opposite*).

Anti-tank scaffolding, a framework of poles nearly 3m high, was also built in the surf zone to prevent assault craft from landing. It would have been difficult for tanks to destroy with cannon fire, and any armoured vehicles pausing to mount the barrier would be exposed to defending fire (Fig 6.4).

Anti-personnel and anti-tank mines were often laid behind the scaffolding, supplemented by a variety of concrete obstacles.

Fig 6.4 Anti-tank scaffolding under construction. (H11546, Photograph courtesy of the Imperial War Museum, London)

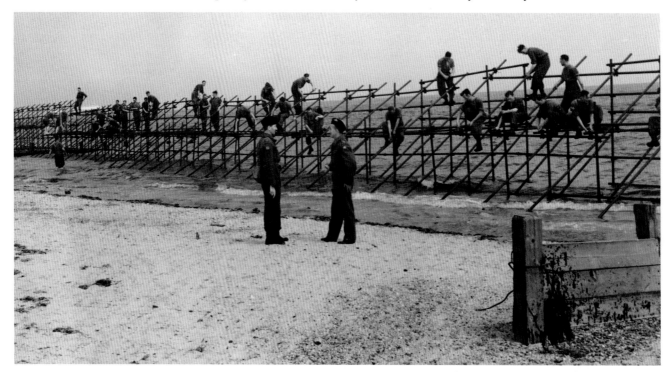

Linear beach defences

Ironside's coastal crust defences are clearly visible in this 1941 photograph of Aldeburgh (*below, top*). The minefields, freshly buried in the shingle, are easily seen from the air. However, once the shingle has been weathered by the tide it forms a deadly hidden barrier. Nationally, it is unknown how extensive anti-tank ditches were but on the Suffolk coast alone, over 30km of anti-tank ditches are visible on aerial photographs, some encircling entire towns as can be seen on this 1943 photograph of Aldeburgh (*below, bottom*).

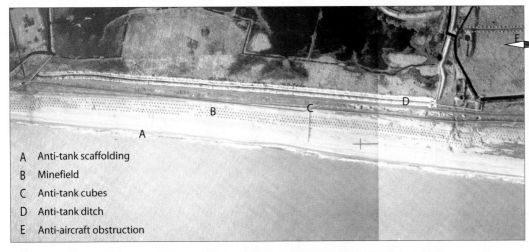

A Anti-tank scaffolding
B Minefield
C Anti-tank cubes
D Anti-tank ditch
E Anti-aircraft obstruction

(RAF 2A/BR167 7,RAF 2A/BR167 8 17-DEC-1941 English Heritage (NMR) RAF Photography)

(US 7PH/GP/LOC132 5048 30-DEC-1943 English Heritage (NMR) USAAF Collection)

57

Woodbridge anti-glider ditches

On Suffolk's coast anti-glider ditches were often integrated with other anti-invasion defences, as at Aldeburgh (*see* p 57). They also covered vast areas of farmland and heath further inland, as can be seen in this 1944 photograph near Woodbridge Airfield. The demands of post-war food production, however, meant that few survived for long (*see* Chapter 8).

(US 7PH/GP/LOC288 12014 19-APR-1944 English Heritage (NMR) USAAF Collection)

The anti-tank cube, usually about 3ft (0.9m) square, was by far the most common defence obstacle on Suffolk's coast. Constructed by the thousands, the cubes were multifunctional. A tank halted by a cube would be a sitting target. Crossing them would potentially damage the tank's tracks and expose its vulnerable underside to defending fire.

By 1941 Ironside's linear anti-invasion defences extended almost the entire length of the Suffolk coast, from Felixstowe to Lowestoft, only breaking where natural features, such as estuaries or cliffs, proved more effective. Nowhere was their linear form more apparent than along the vulnerable, low-lying shore north of Aldeburgh.

Obstructions

In addition to coastal anti-invasion defences, anti-aircraft obstructions were deployed from 1940 to prevent enemy aircraft landing on open land. With wide expanses of field, heath and reclaimed coastal salt marsh, this was a great concern in East Anglia. In Suffolk these defences largely took the form of trenches known as 'Anti-Glider Ditches'.

In actuality the greatest threat came not from gliders but from large troop-carrying aircraft landing near vulnerable, strategically important sites. First built near airbases, the anti-invasion defence schemes of 1940 soon extended these anti-aircraft obstructions to potential landing grounds within five miles (8km) of the coast, particularly near vulnerable ports. Norway's shocking *blitzkrieg* experience suggested that the Luftwaffe could land up to five troop-carrying transport aircraft every 30 seconds, a rate equal to some 20,000 troops per day. Every means of reducing available landing grounds was therefore vital. A variety of obstacles were developed, from felled trees to wire-strung scaffolding poles, but the method reserved for the most vulnerable areas was trenching.

The ditches were specifically designed to combat the most common German transport planes, the Junker 52 and troop-carrying gliders. Official specifications called for fields over 500 × 100yds (about 460m × 90m) to be obstructed, and a grid of ditches 4ft (1.2m) wide, flanked by piles of spoil, to be dug in open areas. Ditches were most disruptive to agriculture and were therefore used only where absolutely necessary. In Suffolk, such ditches covered considerable areas of land.

Bridge on the River Deben

Five pillboxes covered Wilford Bridge at Melton, near Woodbridge, illustrating its importance in General Ironside's initial defensive plans (*right, top and bottom*). Under General Brooke, existing pillboxes were only retained if they could be usefully incorporated into the new schemes alongside fieldworks. Their continued presence at Wilford Bridge in 1944 therefore reinforces its continuing strategic value, although the pillboxes are supplemented by extensive rifle trenches, barbed wire obstructions and road blocks. Some pillboxes may have been intended as decoys.

(US 7PH/GP/LOC288 12014 19-APR-1944
English Heritage (NMR) USAAF Collection)

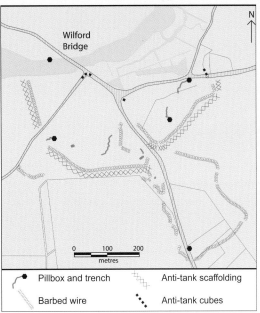

59

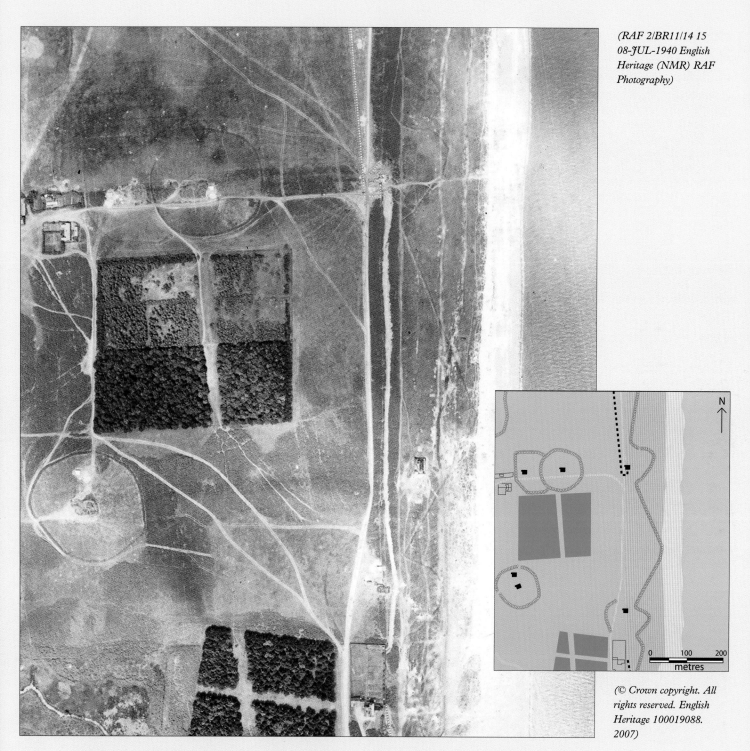

*(RAF 2/BR11/14 15
08-JUL-1940 English
Heritage (NMR) RAF
Photography)*

The evolution of coastal defences

Sizewell's 1940 anti-invasion defences, consisting mainly of barbed wire and pillboxes, typified the development of the coastal crust following the German invasion of France (*above*). By the end of 1941 things had changed. Beach scaffolding now ran along the shore, connecting with new anti-tank cubes. Spaces between new camouflaged pillboxes were filled with complex interlinking barbed-wire entanglements (*opposite*). These defences were maintained until 1944, by which time the threat from Hitler's flying bombs had surpassed that of invasion. By November 1944 a Diver battery and its camp (*see* Operation Crossbow: the Diver threat, p 74) had been established, remodelling the area's defences to face this new threat (p 62).

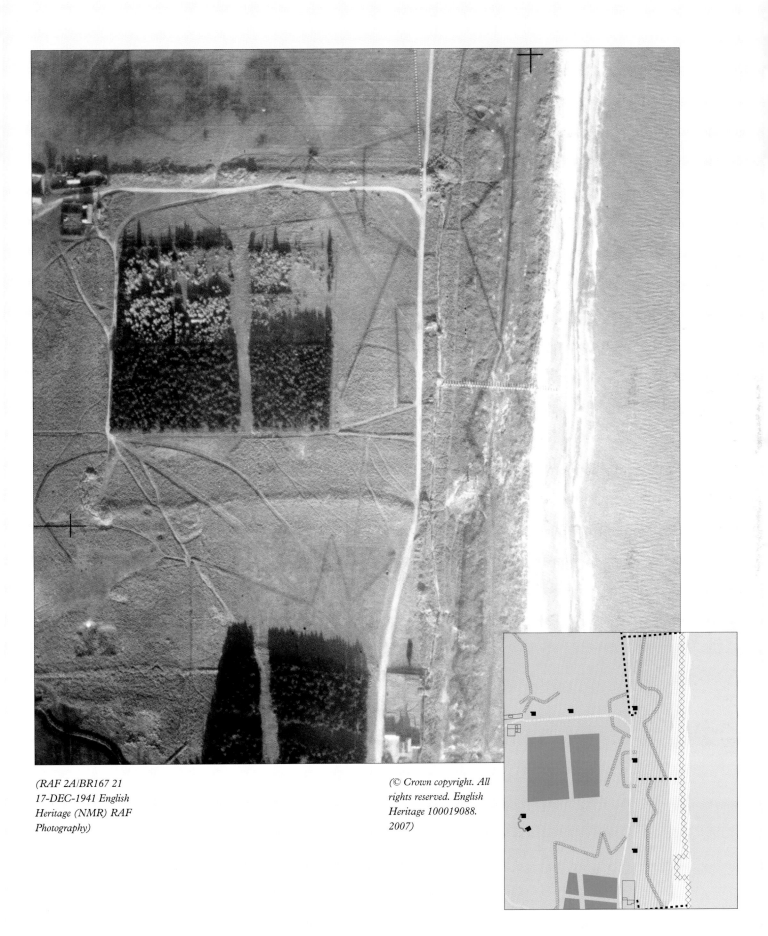

(RAF 2A/BR167 21
17-DEC-1941 English
Heritage (NMR) RAF
Photography)

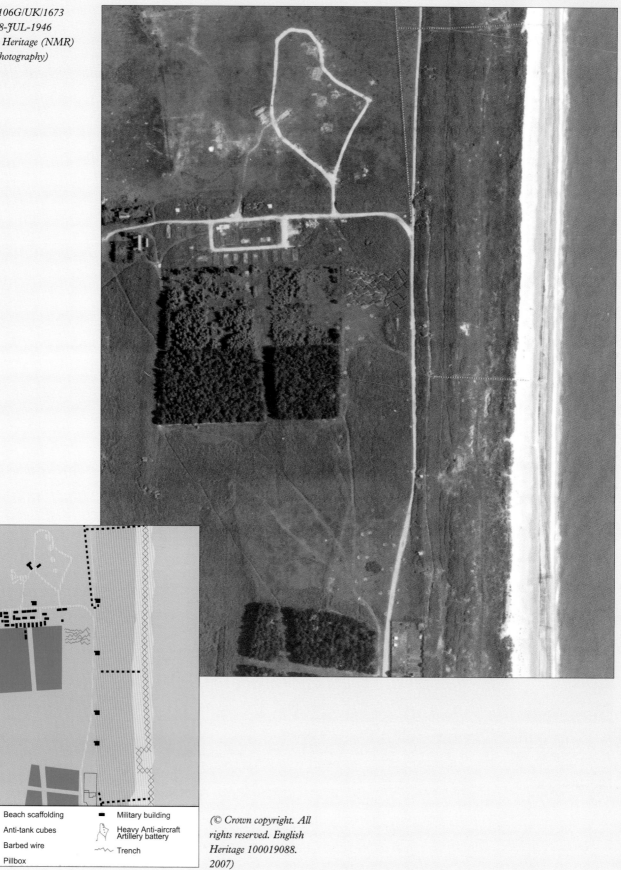

	Beach scaffolding		Military building
	Anti-tank cubes		Heavy Anti-aircraft Artillery battery
	Barbed wire		Trench
	Pillbox		

Anti-tank islands

From July 1940, defence strategy changed under the command of General Brooke. Ironside's beach defences were completed but the construction of new pillboxes ceased. Inland, stop-line strategies were discarded in favour of a system of 'anti-tank islands', carefully identified areas where the Home Guard could best use its limited anti-tank weaponry to frustrate the advance of enemy armoured vehicles. They focused on key towns and infrastructure such as major road junctions and, as at Melton on the River Deben, potentially vulnerable river crossings (see p 59). Wilford Bridge, the lowest crossing point on the River Deben, is only 2.5km to the north-west of Woodbridge airfield. This made it strategically important and ideally suited to use in an anti-tank island. Enough 'anti-tank islands' working together may have been able to slow the feared German *blitzkrieg*.

Germany's assault on Russia and the entry of the US into the war in 1941 eased the threat of invasion. Britain, unable to launch a counter-offensive, took the opportunity to consolidate and expand its anti-invasion defences. General Brooke recognised the importance of defences on the coast, which received investment from increasingly scarce resources. This is apparent in the increasing complexity of defences around Sizewell, on one of Suffolk's most vulnerable stretches of shore (see pp 60–2).

From 1942 onwards, however, it became clear that an invasion was unlikely, and anti-invasion defences were removed in many areas. They were maintained only where snap raids were possible, as on the East Coast. By the end of 1943 the greatest danger to Home Forces and to Allied invasion preparations was Germany's development of long-distance weapons, as discussed later in this chapter (see pp 74–5). This marked the end of the invasion threat, and the final phase in the life of Suffolk's coastal anti-invasion defences.

Stone ships, Desert Rats and training grounds

Training became increasingly important during preparations for the invasion of Europe. Suffolk's low, uncultivated, sparsely populated coastal salt marsh and navigable estuaries were ideally suited to this. Numerous specialised training bases were established here, and the county was to play an important role in bringing the war to an end.

Temporary camps

As training activity increased, so did the need for accommodation, and a range of camps sprang up along Suffolk's coast. Although more temporary in character than other coastal military sites, they were no less important. Wartime food requirements limited the amount of land available for

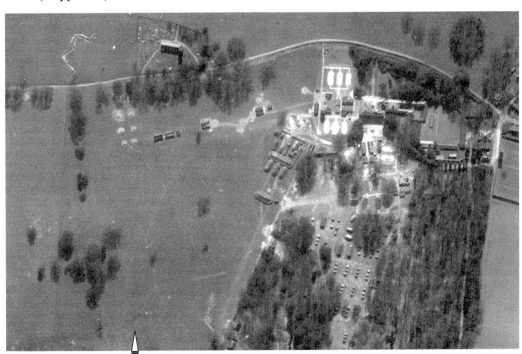

Fig 6.5 A temporary camp in the grounds of Wherstead Hall, near Ipswich, in 1944. (RAF HLA/694 3043 26-MAR-1944 English Heritage (NMR) RAF Photography)

HMS Woolverstone

Photographs of HMS Woolverstone from 1944 show Nissen Huts (i) around the hall and the embarkation hard (ii) on the river bank (*below, left*). At first the hall probably provided accommodation for operational staff, but as D-Day approached and training intensified, more accommodation would have been required. Most of the huts near the hall are probably barracks for troops being trained at the base, while those closest to the embarkation hard housed the operational command centre and workshops. Two large circular tanks surrounded by earthwork banks probably held fuel for the amphibious craft. Although not used on D-Day, HMS Woolverstone contributed to the

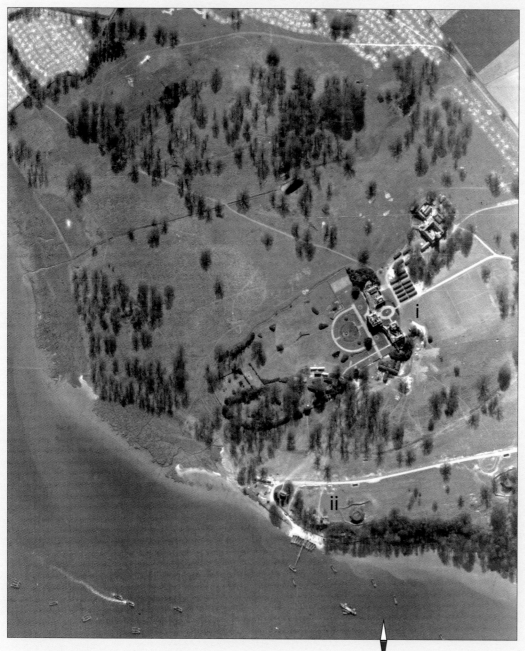

(RAF HLA/694 3054 26-MAR-1944 English Heritage (NMR) RAF Photography)

(RAF 106G/LA/23 3052 06-JUL-1944 English Heritage (NMR) RAF Photography)

invasion preparation by manufacturing dummy landing craft, as seen here on the River Orwell (*below*). These were used to mislead German reconnaissance into believing that a large invasion force was being assembled, away from the true embarkation sites.

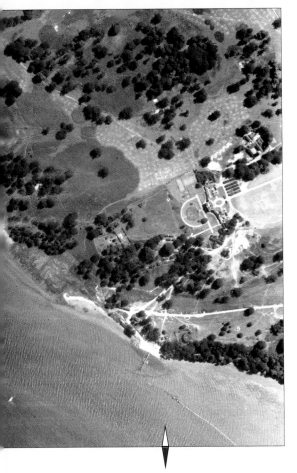

military use, and consequently many large country estates were requisitioned. The tents of a temporary camp are visible in aerial photographs of Wherstead Hall, near Ipswich, for example (Fig 6.5).

Although it is not always possible to identify the purpose of a camp from aerial photographs, some conclusions can be drawn. For example, the number of tents visible at Wherstead Hall varied from spring to summer of 1944, suggesting that it may have been a transit camp associated with the D-Day landings of 6 June. In other cases it has been possible to associate temporary sites with specific purposes or important contributions to wartime events.

HMS Woolverstone

The landscaped grounds of the late 18th-century Woolverstone Hall, on the outskirts of Ipswich, is one of several estates on the banks of the River Orwell. Acquired by the War Office at the start of the war, Woolverstone was initially used for artillery training. In 1943 it became an Admiralty base. In naval tradition shore bases are named in the same style as vessels, and the estate therefore became known as HMS Woolverstone, one of the Royal Navy's fleet of 'stone ships'.

The strategic importance of this site was highlighted early on by its inclusion in a scheme initiated in 1942 by Winston Churchill. Under Churchill's guidance, the Chief of Combined Operations, Lord Louis Mountbatten, ordered the construction of landing-craft embarkation points – concrete slopes called 'hards' – on shores and river banks from East Anglia to south Wales. By the summer of 1943 nearly 70 hards had been built, 4 of them in Suffolk. One was near Cat House in the grounds of HMS Woolverstone.

These hards, and the troop-carrying amphibious landing craft which used them, were integral to the development of Combined Operations (CO), a new type of military action in which all three armed services cooperated to place forces onto hostile beaches for the purpose of either raiding or establishing invasion beach-heads. CO was integral to Operation Overlord, the Allied invasion of Europe, and HMS Woolverstone became a base for landing-craft training. Although the base was not to play a direct part in the D-Day landings, other less obvious but no less important tasks were carried out here.

Embarkation hards were also built at Felixstowe for loading tanks onto larger landing craft called Landing Ships Tanks (LST). These were more directly connected with another temporary camp and with the events of June 1944, as will be seen in the following section.

Rats in the park

The estate of Orwell Park, which faces HMS Woolverstone across the River Orwell, was requisitioned when war was declared, and used for various training purposes. Beginning in the spring of 1944 an extensive tented camp was established here. This was a concentration area for troops marshalling for Operation Overlord, including one of the war's most famous divisions, the Desert Rats.

Following their famous North African campaign, three regiments of the Desert Rats – more formally known as the 7th Armoured Division – were stationed in Thetford Forest, Norfolk, where they began preparations for D-Day, occasionally travelling to a firing range near Orford for live practice in their new Cromwell and Sherman tanks. On 8 May they moved to Orwell Park, which was close enough to the embarkation hards of Felixstowe for easy transport but far enough away to avoid attracting enemy attention. It was at Orwell Park that last-minute preparations were made, vehicles were waterproofed and the final invasion plans unveiled to the unit's officers.

The construction of the camp can be seen on aerial photographs from 1944 (*opposite*). The camp contains a number of Nissen Huts, which may have originated with earlier training activities, but is dominated by bell and marquee tents. These are concentrated on the open parkland between the main house and the river, although military activity can also be seen around the house and elsewhere on the estate. The park provided good cover; some tents were located in wooded areas for camouflage, and the layout of smaller tents imitates the formal planting of the park's trees. The camp was top secret, and it is probable that its layout was not recorded. This alone makes the aerial photographic evidence important.

As D-Day approached, the regimental war diary entry for 27 May states, 'All ranks now confined to camp area'. One trooper, Les Dinning, remembered this as a time of enforced inactivity: 'There was very little to do in the concentration camp, other than to play football, cricket during the day and Housey Housey (Bingo) in the NAAFI.' At the end of the month the Desert Rats' tanks marshalled along the Ipswich Road and travelled to Felixstowe where they boarded LSTs moored at the embarkation hards. On 5 June they departed for Normandy. The Desert Rats joined the campaign to liberate occupied Europe by landing on Gold Beach on the evening of 6 June 1944.

The five months in 1944 was the only period in their history that the Desert Rats spent in Britain. The final three weeks were at Orwell Park. This camp was being dismantled by July of the same year, and leaves little or no trace on the ground today. Aerial photographs provide a fascinating insight into this and other similar temporary sites in Suffolk. Although short-lived, they played an important role in changing the course of the war.

Battleground Suffolk

The pre-war years were a period of rapid expansion for the British Army as they struggled to keep pace with Germany's military growth. This included a switch from horses to horsepower, culminating in the creation in 1939 of the Royal Armoured Corps (RAC). With this expansion, and particularly whilst preparing for the invasion of Europe, the Desert Rats and other armoured units needed training areas. The largely uninhabited coastal marshland around Orford was one of a number of locations identified as potential training sites.

Early in 1943 an Armoured Fighting Vehicle (AFV) range was constructed on a wide expanse of salt marsh at Boyton, approximately 4km south-west of Orfordness. It was used throughout the war for basic training and firing practice by armoured units of Eastern Command, before they were moved to larger War Office ranges elsewhere in the country, such as Warcop or Kirkcudbright. The range saw increased action in the build-up to Operation Overlord, soon after which it ceased to operate. Only a few isolated blockhouses can now be seen on the ground.

The firing range did not operate in isolation but was part of a wider landscape given over to military training, known as

Orwell Park

The extent of the camp in Orwell Park emphasises the huge number of military personnel that must have been stationed here. Its population may have necessitated the construction of the sewage plant on the banks of the river to the south-east of the camp. Areas of hard standing probably identify workshops where vehicles were water proofed before Operation Overlord. The camp continued in use as a transit camp for only a short time after the invasion, soon becoming redundant. This is reflected in the number of tents that have been dismantled by the time of this photograph (July 1944). Such aerial photographs illustrate little-known behind-the-scenes preparations for an important phase of Operation Overlord.

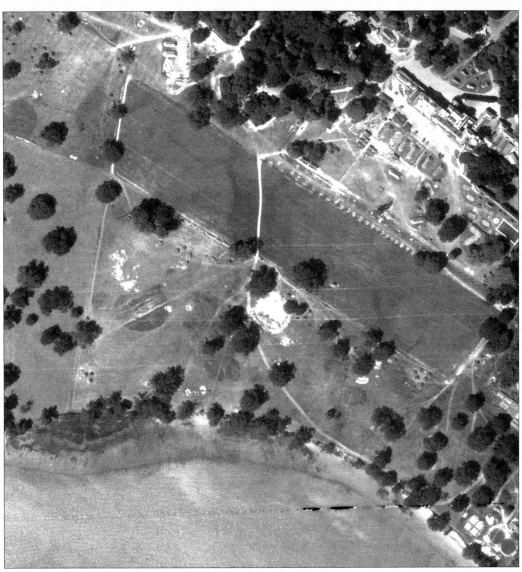

(RAF 106G/LA/23 3049 06-JUL-1944 English Heritage (NMR) RAF Photography)

Boyton AFV range

The Armoured Fighting Vehicle (AFV) range at Boyton, 4km south-west of Orfordness, was typical of those built to cope with increased training requirements towards the end of the war. By the end of 1943 Boyton had become a complex facility. Whilst driving around a triangular track (a) tanks would fire in a south-easterly direction at a variety of targets. Small blockhouses (b) closest to the trackway controlled the appearance of, and recorded hits on, flip-up machine-gun targets (c). Larger blockhouses (d), built into substantial earthwork banks (e), controlled tank-shaped moving targets towed along narrow-gauge tracks behind the banks, as well as additional, probably larger, flip-up targets (f). Any misses would have fallen harmlessly into the sea. Many of these structures and earthworks were destroyed during the expansion of post-war agriculture onto the salt marsh, but the largest of the blockhouses still survive as reminders of an explosive past (*see* Fig 8.4).

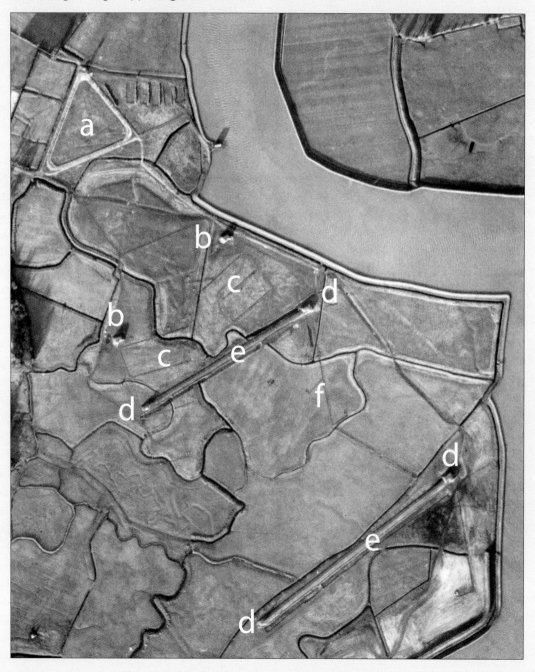

(US 7PH/GP/LOC132 5018 30-DEC-1943 English Heritage (NMR) USAAF Collection)

Orford Battle Area

The effect on the landscape of intensive armoured-vehicle training was dramatic. Yarn Hill, to the east of Iken village, displays numerous shell craters in 1945 (*right*). The damage caused by tanks weighing up to 40 tons (about 36 metric tons) as they tore across heath, marsh, the gardens of evacuated residents and even earlier anti-glider ditches can be seen nearby in the same year (*below*). Despite the promises of the War Office, the inhabitants of Sudbourne and Iken were forced to take legal action to regain their often badly damaged homes following the war.

(RAF 106G/UK/929 3308 16-OCT-1945 English Heritage (NMR) RAF Photography)

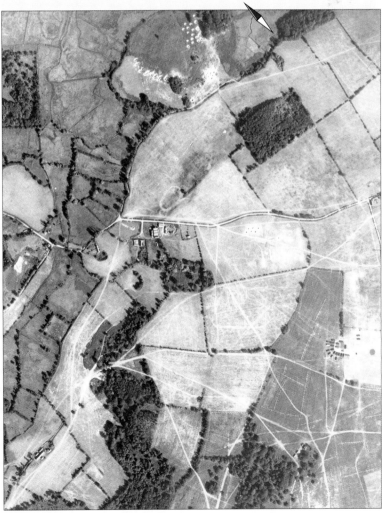

(RAF 106G/UK/832 3154 23-SEP-1945 English Heritage (NMR) RAF Photography)

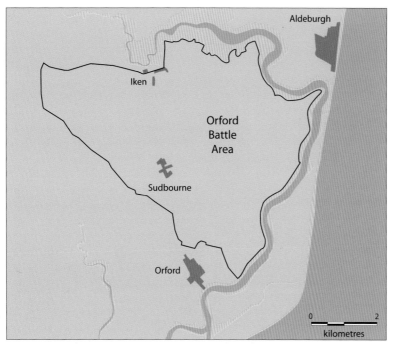

Fig 6.6 Orford Battle Area. (© Crown copyright. All rights reserved. English Heritage 100019088. 2007)

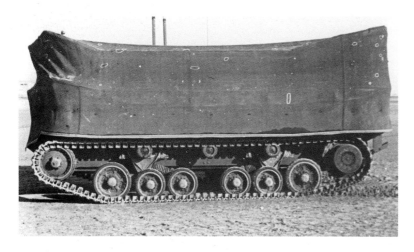

Fig 6.7 Duplex-drive amphibious tanks. (342_D2 and 342_D1 The Tank Museum)

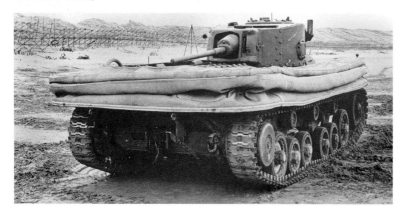

the Orford Battle Area, which enclosed almost 3,200ha (12 sq mi) of land, incorporating the villages of Iken and Sudbourne (Fig 6.6). Troops were provided with tented accommodation in a temporary camp in the grounds of Sudbourne Hall. The hall itself housed the officer's mess and the headquarters of the battle school.

The training area had a massive impact on the landscape and the lives of the people who lived on this stretch of coast. Iken, Sudbourne and their environs were completely evacuated, and many village residents never returned. Training activities scarred the landscape and damaged local property, although the damage was not done solely by tanks. To recreate battlefield conditions, naval warships fired live shells into the battle area. On one occasion in April 1944, the realism came too close for comfort for residents of neighbouring Aldeburgh when the Royal Navy's aim was slightly off target and substantial damage was caused to the town.

Hobo's Funnies

Orford Battle Area was also at the forefront of developments in military technology and techniques, which arguably produced Suffolk's most important contribution to Operation Overlord. Between the Allied retreat from Dunkirk in 1940 and the preparations for Operation Overlord in 1944, German occupying forces constructed the 'Atlantic Wall', their own coastal fortifications stretching from Norway to the Spanish border. In 1942 a Canadian raid on Dieppe tested the strength of the Atlantic Wall, with terrible consequences. Their tanks were unable to leave the beach, and the Canadian infantry and engineers took high losses as they tried to clear defences without cover. This experience prompted British experiments into modified tanks that could help clear the beach of enemy defences whilst providing support for infantry.

In 1943 these trials were consolidated in the 79th Armoured Division, under the command of Major-General Sir Percy Hobart. To avoid repeating the experience of Dieppe it was realised that the safest way for engineers to clear beach defences was with modified armoured vehicles which could simultaneously provide cover and carry the necessary equipment for the task. These vehicles, based upon the Churchill tank, were known as Armoured Vehicle Royal Engineers (AVREs). Their often unusual modifications gave them, and Hobart's division, the nickname 'Hobo's Funnies'.

Hobo's Funnies

Innovative mine-clearing techniques were developed by Hobart's engineers at the Orford Battle Area. The 'Snake', an explosives-filled iron tube pushed ahead of an AVRE, was designed to clear a mine-free path (*below left, top and bottom*). The flail tank (*below right, top*), the mine-clearance method actually used on D-Day, was also developed at Orford. An AVRE could carry a bridge -- or even become a bridge itself, as with the Armoured Ramp Carrier known as the 'Ark', seen here bridging a dummy sea wall (*below right, bottom*). Aerial photographs of the Orford Battle Area in 1945 show evidence of weapons testing (*overleaf, top*) and a much-abused dummy sea wall (*overleaf, bottom*), testament to the efficacy of the new techniques.

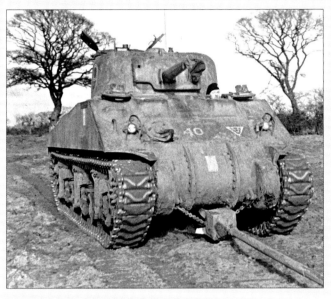

(371_F2 The Tank Museum)

(352_E2 The Tank Museum)

(124_D1 The Tank Museum)

(2118_A5 The Tank Museum)

71

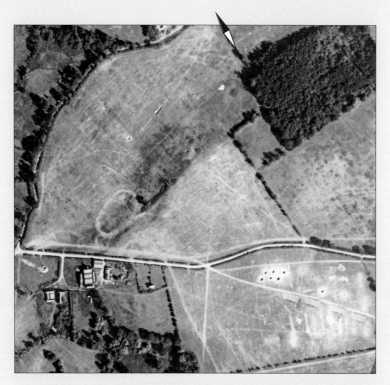

(RAF 106G/UK/832 3154 23-SEP-1945 English Heritage (NMR) RAF Photography)

(RAF 106G/UK/832 4122 23-SEP-1945 English Heritage (NMR) RAF Photography)

Hobart established his headquarters at Saxmundham, Suffolk, in 1943, and three training areas were established in the county. Whilst stationed in Suffolk the 1st Assault Brigade, Royal Engineers, 79th Armoured Division, developed various modified tanks and finalised techniques for beach assault and beach defence clearing. Fritton Decoy near Lowestoft, for example, was the training location for launching and landing duplex-drive amphibious tanks (Fig 6.7), which would enable the regiment to provide infantry with immediate cover.

It was in the Orford Battle Area, however, that real solutions to Hitler's Atlantic Wall were developed. Full-scale replicas of German defences – minefields, strongpoints, barbed wire, ditches, even a replica sea wall nearly 1km in length – were built here, and engineers developed specialised vehicles to overcome each obstruction. This included replacing AVREs' guns with armour- or concrete-shattering mortars, testing novel minesweeping techniques, and innovative methods for bridging obstacles.

On a visit to Suffolk in January 1944 General Eisenhower, the American Commander in Chief, was impressed with the Funnies, most particularly the amphibious tanks. Beyond accepting amphibious tanks in their assaults on Omaha and Utah beaches, however, the Americans declined the Funnies' help. As the Funnies cleared enemy defences and provided support for troops on D-Day beaches, the experience gained by the division in Suffolk undoubtedly saved many British and Canadian lives.

Operation Crossbow: the Diver threat

By 1944 the threat of invasion and aerial attack was fading, but while Allied attention was focused on preparations for the invasion of Europe, a new threat from the air was growing. In the spring of 1943 Allied intelligence had received information about a new long-range German weapon that threatened D-Day preparations, and by 1944 its existence had been confirmed. The effort to counter the Germans' new rocket weapons was code-named Operation Crossbow.

Enraged by Allied bombing of the historic German port of Lübeck in early 1942, Hitler ordered the Luftwaffe to launch retaliatory 'terror' attacks on British historic towns and cultural centres. These came to be known as the 'Baedeker Raids', after tourist guidebooks of the day. At the same

time Hitler revived research into long-distance pilotless weapons. First called *versuchmuster* ('experimental types') they soon came to be known as *vergeltungswaffer* ('reprisal weapons'), or Hitler's Vengeance Weapon. At this point in the war their psychological impact was greater than their strategic threat. The first of these weapons to threaten Britain was the V1 Flying Bomb.

By December 1943 it was clear that defence was required against the Flying Bomb. By January 1944 the 'Kentish gun belt' was established to protect London, alongside an 'aircraft fighting zone', balloon barrages and searchlights. A greater fear was that the new German weapons might target D-Day embarkation points; even London's security was a secondary priority to that of Operation Overlord. In the end this fear was groundless: the first V1s were launched against Britain a week after D-Day, on 13 June 1944.

The doodlebug

The German V1 Flying Bomb ('Diver' to the RAF, or 'doodlebug' as it came to be known) was a pilotless aircraft powered by a pulse-jet engine, launched by catapult from a ramp or from an aircraft in mid-air. It could reach speeds of up to 400 miles per hour (about 640 km per hour) and altitudes of 4,000ft (about 1220m). With a range of over 150 miles (240km) it was capable, if launched from northern France or Holland, of carrying a one-ton warhead to London. As many as 10,000 V1s were launched, over half of them reaching Britain, although only a small proportion reached the capital, their intended target. Of the doodlebugs that reached Britain's shores, almost 2,000 were destroyed by anti-aircraft guns of the Diver batteries.

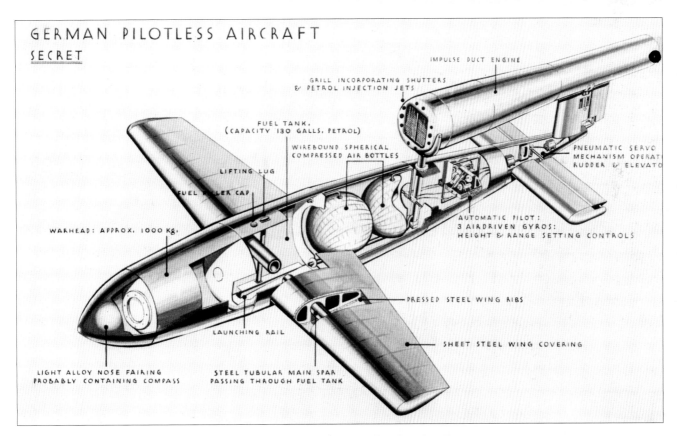

GERMAN PILOTLESS AIRCRAFT
SECRET

IMPULSE DUCT ENGINE

GRILL INCORPORATING SHUTTERS & PETROL INJECTION JETS

FUEL TANK, (CAPACITY 130 GALLS, PETROL)

WIREBOUND SPHERICAL COMPRESSED AIR BOTTLES

LIFTING LUG

FUEL FILLER CAP

WARHEAD: APPROX. 1000 Kg.

LIGHT ALLOY NOSE FAIRING PROBABLY CONTAINING COMPASS

LAUNCHING RAIL

STEEL TUBULAR MAIN SPAR PASSING THROUGH FUEL TANK

PRESSED STEEL WING RIBS

SHEET STEEL WING COVERING

AUTOMATIC PILOT: 3 AIRDRIVEN GYROS: HEIGHT & RANGE SETTING CONTROLS

PNEUMATIC SERVO MECHANISM OPERAT RUDDER & ELEVATO

(C4431, photograph courtesy of the Imperial War Museum, London)

Divers on the Suffolk coast

By July 1944 General Pile, Commander in Chief of AA Command, received authorisation to redeploy HAA guns to counter this new threat. This was the beginning of Operation Diver. 'Diver batteries' differed from conventional anti-aircraft batteries. Urgency demanded that they be built as quickly as possible, so guns were mounted on temporary 'Pile Platforms' built from steel rails and timber sleepers, rather than in large concrete emplacements. A battery's four guns were arranged either in a flattened V, with flanking guns set forward to allow lower firing, or in a straight line, directly across the path of incoming V1s. Both arrangements are easily recognisable on aerial photographs.

Diver guns were first deployed to a southern Coastal Gun Belt, and soon to the Diver Box around the Thames Estuary. As the Allies advanced into Europe further redeployments were required as V1 launches retreated, first to Holland, then to northern Germany. Finally, in mid-September the Luftwaffe recommenced air launches of the V1, this time over the East Coast. Despite the liberation of Europe sapping AA Command's resources, the Coastal Gun Belt was closed on 22 September and its armaments diverted to the East Coast to form the Diver Strip.

The Diver Strip

The Diver Strip extended from the Diver Box at Clacton-on-Sea, Essex, to the Lowestoft–Yarmouth Gun Defence Area in the north. It had a massive impact on Suffolk's coastal landscape. According to documentary evidence 85 Diver Strip batteries were established, of which 72 have been located on aerial photographs of Suffolk (Fig 6.8). The firing zone extended 5,000yds (4,570m) inland and 10,000yds (9,140m) out to sea. Even Allied fighters could not enter this area for fear of being destroyed.

The density of these batteries in Suffolk is apparent in the previously undefended area around Orford. Before September 1944 no HAA batteries had been built between Aldeburgh and the Butley River. Military records state that by the end of 1944 the Diver Strip had established 11 new batteries in this area. Aerial photographs reveal that there were actually 13 in this area, significantly improving our knowledge of their distribution (*see* Fig 8.3).

The redeployment of the Diver guns to the East Coast was difficult. Expected to take 4 days, it took 22. Poor planning, coordination and communications were partly to blame for the confusion and delay. However, General Pile identified one reason that will still be familiar to many drivers in the Suffolk countryside today: 'On the narrow twisting roads in that part of East Anglia where we were redeploying, convoys of ten tonners would suddenly encounter head on convoys of three tonners. The subsequent delay and confusion were enormous' (Pile 1949, 372).

As the war progressed the Diver batteries made use of gun-laying radar. Since the beginning of the V1 threat, General Pile had insisted on using superior American radar and predictors where possible, which would allow fully automatic tracking and aiming of the AA guns. By the time the Diver Strip was established all batteries were equipped with this equipment. The Diver Strip proved very effective, with experienced gun crews reporting a strike rate of over 80 per cent. The last V1 of the war was shot down by a Diver battery near Orfordness on 29 March 1945.

Fig 6.8 East coast Diver Strip batteries in Suffolk. (© Crown copyright. All rights reserved. English Heritage 100019088. 2007)

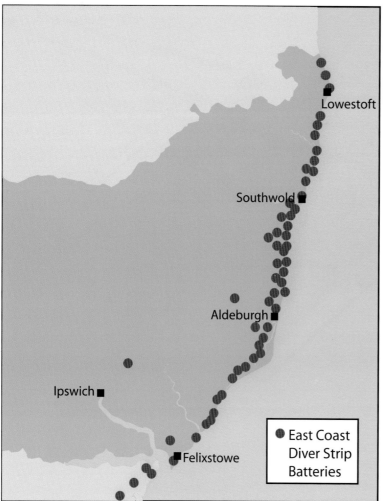

● East Coast Diver Strip Batteries

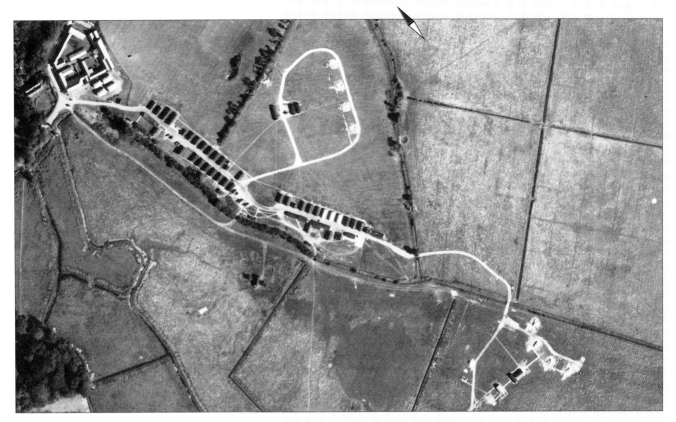

The end of the Second World War in Europe

Aerial photographs have illustrated how Suffolk's coastal defences responded to the new strategies and technologies of the Second World War. From the anti-invasion defences of 1941 to the response to the V1 Flying Bomb, aerial photographs offer insights which are often unavailable from other sources. These insights are increasingly valuable as surviving defences are accepted and studied as part of our historic environment.

Stalin's army reached Berlin in April 1945 and the Second World War in Europe was effectively over by early May. Two developments from the end of the Second World War, however, foreshadow Suffolk's post-war defences. Firstly, before his defeat Hitler's second Vengeance Weapon, the V2 rocket, had begun to strike at London with almost complete impunity. Anti-aircraft defences which had coped so admirably with the V1 were practically useless against this new missile. Secondly the United States' use of nuclear weapons against Japan ended the Pacific War. In combination, these new technologies raised the bar for future conflicts, and as will be seen in the next chapter, shaped Suffolk's coastal defences for the next 40 years.

The Diver batteries

Some Diver batteries, such as this one near Orford, incorporated both 'V' and linear gun formations. This may indicate multiple phases in the development of the site. It is clear from aerial photographs that Diver Strip camps did not adhere to a single layout in Suffolk, but fitted as best they could within existing defences and the complex, irregular coastal landscape.

(RAF 106G/UK/832 3164 23-SEP-1945 English Heritage (NMR) RAF Photography)

7
The Cold War era

A new era dawns

At the end of the Second World War much of Britain's military defence system was downgraded or abandoned. This process actually began during the later years of the war, when it became clear that the threat of enemy invasion was receding. It was undertaken with increasing speed at the end of the war when, in May 1945, any lingering doubts about Germany's military capabilities were removed and control of the country was divided between Britain, the United States, the Soviet Union and France. Western leaders, particularly those of Britain and the United States, however, were increasingly concerned about the threat posed by Stalin and his vision of a Communist-dominated Europe. In particular it was feared that Stalin might acquire the technology to develop atomic bombs, such as those used on Japan by the United States in August 1945.

Though Roosevelt and Churchill had united with Stalin in order to defeat Germany, it soon became clear that the ideologies of the Soviet Union and the political powers of Western Europe and the United States were fundamentally at odds. The division of Germany into what was effectively to become West Germany and Soviet-controlled East Germany created a barrier across Europe between the Western-looking capitalist countries and the Eastern Communist states. The Cold War period was dominated by this ideological, political

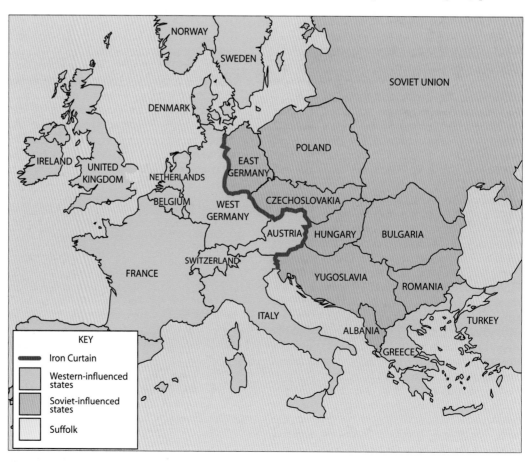

Fig 7.1 Europe's political divisions in 1945. The Suffolk coast had an important strategic location, facing the Eastern Bloc countries.

KEY

Iron Curtain

Western-influenced states

Soviet-influenced states

Suffolk

and physical barrier – the 'Iron Curtain' – dividing East and West, Communism and capitalism (Fig 7.1).

United States policy towards the Soviet Union dominated Europe's defence strategy throughout the Cold War period. Initially the US aimed to prevent the spread of Communism across Europe by rebuilding the war-damaged countries, in order to avoid economic conditions in which they thought Communism might flourish. By 1949 the North Atlantic Treaty Organisation (NATO) had been formed between the US and countries of Western Europe, and in 1955 the Soviet-influenced countries of Eastern Europe signed the Warsaw Pact treaty, representing a formalisation of East–West political divisions and acceptance that an act of aggression against one state would be seen as an act of aggression against all members of its treaty organisation. The nuclear arms race had truly begun.

Military defence during the Cold War

The development of the atomic bomb towards the end of the Second World War changed the nature of warfare forever. Direct invasion of the United Kingdom was no longer the major preoccupation of defence strategists; a new age of 'Mutually Assured Destruction' had begun. At the start of the Cold War both the US and the UK adopted defence policies whose underlying principle was that the only deterrent against nuclear weapons was bigger and better nuclear weapons. This policy was maintained until well into the mid-1960s, when it was replaced by a strategy of 'Flexible Response', allowing more moderate reactions to acts of aggression, rather than all-out nuclear war.

The policy of Mutually Assured Destruction propelled the development of bombs, jet fighters, radar and other defence technologies forward apace as the West strove to keep up with technological developments apparently occurring in the USSR, and vice versa. These developments precipitated changes on military sites across the country, including those on the Suffolk coast – for example the upgrading of airfield infrastructure at Bentwaters and Woodbridge to accommodate heavier American fighters.

As in the Second World War, military installations on the Suffolk coast continued to play a vital part in the Cold War. There were a number of reasons for this continuing military importance. Despite the general downgrading of anti-invasion defences, mili-

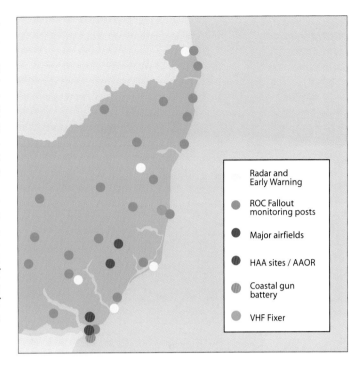

tary defence was maintained in the so-called Main Defended Area. In the early years of the Cold War the East Coast remained within the Main Defended Area because of its vulnerable geographical location and the importance of ports such as Harwich for troop embarkation. While this same vulnerability led to the siting of many Cold War facilities further inland, the fact that a number were nevertheless sited on the Suffolk coast (Fig 7.2) reflects a legacy of Second World War and earlier facilities which could be reused. These were either easily adapted to the demands of post-war defence or perhaps, as at Orfordness, far from major population centres and therefore ideal for the maintenance of security and secrecy.

Early warning

The radar coverage which had proved so vital during the Second World War (*see* Chapter 6) was also downgraded in the immediate post-war era although, as with HAA batteries, coverage was maintained in the Main Defended Area. Initially, small alterations were made to existing Second World War sites until, in the early 1950s, an ambitious upgrade of the country's radar systems, known as the Rotor programme, was undertaken. Two Second World War radar sites remained in use on the Suffolk coast in the Cold War period: Hopton, a Chain Home Extra Low (CHEL) site on Suffolk's border with Norfolk (Fig 7.3), and

Fig 7.2 Cold War military sites on the Suffolk coast. (© Crown copyright. All rights reserved. English Heritage 100019088. 2007)

Legend:
Radar and Early Warning
ROC Fallout monitoring posts
Major airfields
HAA sites / AAOR
Coastal gun battery
VHF Fixer

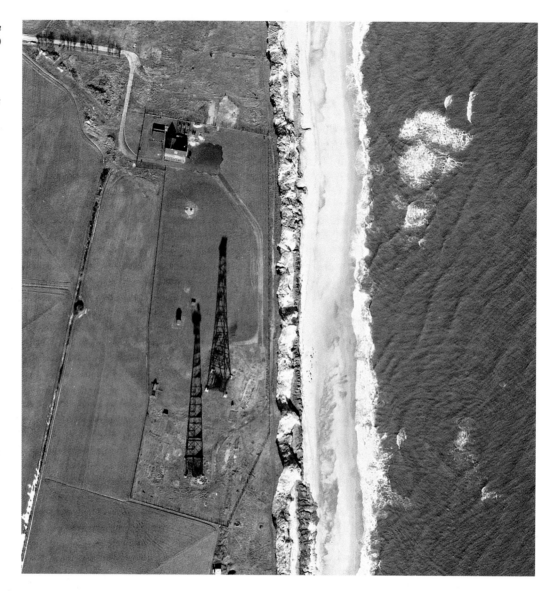

Fig 7.3 The Hopton Chain Home Extra Low (CHEL) radar site in 1955. CHEL was the general term for radar that worked at wavelengths of 10cm or less and gave coverage at sea level. The Second World War buildings on the site have been replaced by an underground operations block but the shadows cast by the two reused Second World War masts are clearly visible. (RAF 58/1672 F21 0028 03-MAR-1955 English Heritage (NMR) RAF Photography)

Bawdsey, where important developments in radar technology had taken place before and during the war.

In the earlier years of the Cold War Bawdsey continued to operate as a Chain Home (CH) and Ground Controlled Interception (GCI) radar site but, as early warning technology developed, it was equipped with gradually more powerful systems until the equipment was finally moved to another location in 1970 (Fig 7.4).

To supplement radar coverage, particularly of low-flying aircraft, the Royal Observer Corps (ROC) made vital visual observations of the sky during the Second World War. As the Suffolk coast represented a potential line of attack for German and later Soviet aircraft, the posts on this stretch of coast played a particularly important role. However, in a pattern similar to that for

HAA batteries and radar sites, ROC posts were rapidly decommissioned at the end of the war, only to be revitalised in the late 1940s as Cold War tensions developed.

ROC posts maintained their visual-observation role until the mid-1950s when the Corps took on the new role of monitoring fallout in the event of a nuclear strike, and was equipped with new underground monitoring posts. There were eight ROC posts on the Suffolk coast, including ones positioned close to the ports and harbours at Aldeburgh, Lowestoft and Felixstowe, where it was feared that nuclear weapons dropped at sea might generate tidal waves. These sites are difficult to locate on aerial photographs, as they consisted of underground reinforced concrete bunkers, with only small access and ventilation shafts visible above ground. Many still survive and

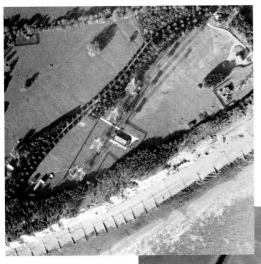

Fig 7.4 Bawdsey Radar Station. View in 1965 (right). The remaining masts and buildings of the original Chain Home (CH) station, which functioned during and after the Second World War, are still visible in the centre of the photograph. In later years the CH set was replaced by more advanced radar. In the far north of the site the Ground Controlled Interception (GCI) site is visible. (MAL/65097 002 06-NOV-1965 © Crown copyright. NMR)

The four transmitter masts and embanked transmitter block of the CH station in 1949 (inset, top). (RAF 541/367 3058 31-OCT-1949 English Heritage (NMR) RAF Photography)

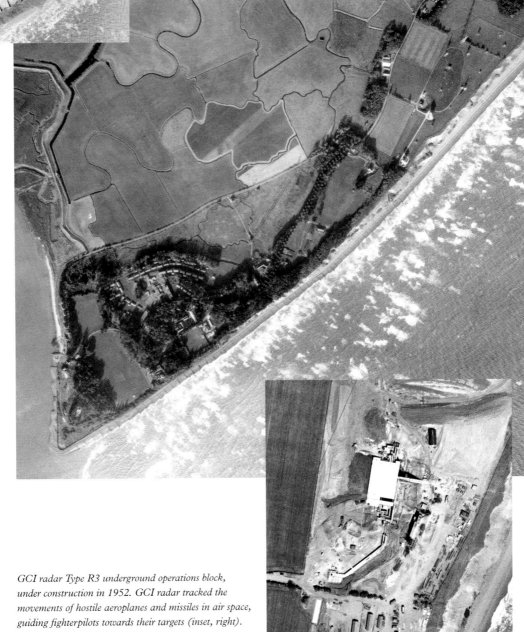

GCI radar Type R3 underground operations block, under construction in 1952. GCI radar tracked the movements of hostile aeroplanes and missiles in air space, guiding fighterpilots towards their targets (inset, right). (RAF 58/877 5027 21-MAY-1952 English Heritage (NMR) RAF Photography)

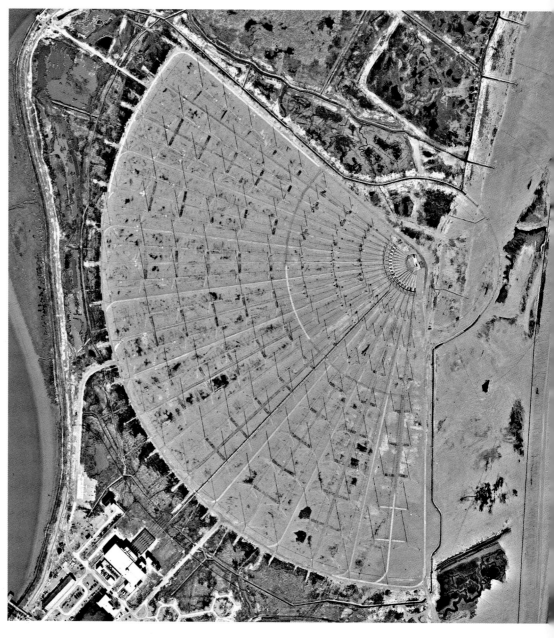

others have had their surface vents demolished and levelled, while the one at Southwold has been lost to coastal erosion.

Orfordness is a large isolated shingle spit which stretches along the Suffolk coast from Aldeburgh to Shingle Street. Its long and varied military history, discussed in earlier chapters, includes experiments by the Royal Flying Corps, research on ballistics and, briefly, radar. By the 1960s developments in missile technology meant that relatively little warning was available in the event of a nuclear strike. One method of detecting a distant launch is Over-The-Horizon (OTH) radar, which bounces signals off the ionosphere, collecting back-scatter from objects in the signal's path. OTH radar has a much greater range than earlier systems and therefore increases the time between the detection of a launch and a strike.

In 1964 it was decided that Orfordness would be the site of a new Anglo-American OTH radar system, to be called Cobra Mist. It was 1968 by the time all the bombs from Second World War experiments on the Ness had been cleared and construction of the radar could begin. The site was dominated by an 18-fingered antenna fan that covered over half a square kilometre of the spit (Fig 7.5). The system was abandoned in 1973 as persistent problems with background noise rendered it ineffective (Fig 7.6).

Defence against attack

The immediate post-Second World War defence strategy in Britain manifests itself on the Suffolk coast at Searson's Farm, Trimley St Mary, just north-west of Felixstowe (Figs 7.7 and 7.8). After the war Heavy Anti-aircraft Artillery (HAA) batteries were vastly reduced in number, the remainder becoming part of what was known as the Nucleus Force. These batteries were generally located to defend major urban areas and other strategic targets against bomber aircraft. The Trimley St Mary battery was part of the defences for Harwich, its guns initially controlled from a command centre in Landguard Fort and later from a purpose-built Anti-aircraft Operations Room at Mistley, Essex. The original HAA battery at Trimley was demolished in 1946 and a new one constructed just to the north-west, equipped with larger 5.2-inch guns capable of hitting high-flying aircraft. Though HAA batteries became obsolete in the 1950s, this Cold War battery highlights the continuing importance of the Suffolk coast in defence strategies of the immediate post-war era.

In the late 1950s HAA batteries were abandoned in favour of guided missiles. Bloodhound surface-to-air missiles were designed to intercept a new generation of Soviet jet bombers armed with nuclear weapons. Initially Bloodhound Mark I missiles were set back from the coast at Watton, Marham and Rattlesden, but would be directed to their targets by coastal radars, including the station at Bawdsey. In 1979, in one of the last developments relating to Cold War defence on the Suffolk coast, 12 Bloodhound Mark II missiles, which had a larger warhead and a greater range, were installed at Bawdsey, in the layout of concrete hard standings typical of the Bloodhound sites (Fig 7.9). A number of other purpose-built structures, including tactical radar, stores and operations rooms, were also built on the site.

Fig 7.6 Site of the Cobra Mist OTH radar array in 2002, with the town of Aldeburgh visible in the distance. The fan pattern can still be seen on the ground, although the present-day aerials serve the BBC World Service, who now occupy the site. (NMR 21887/16 07-NOV-2002 © English Heritage.NMR)

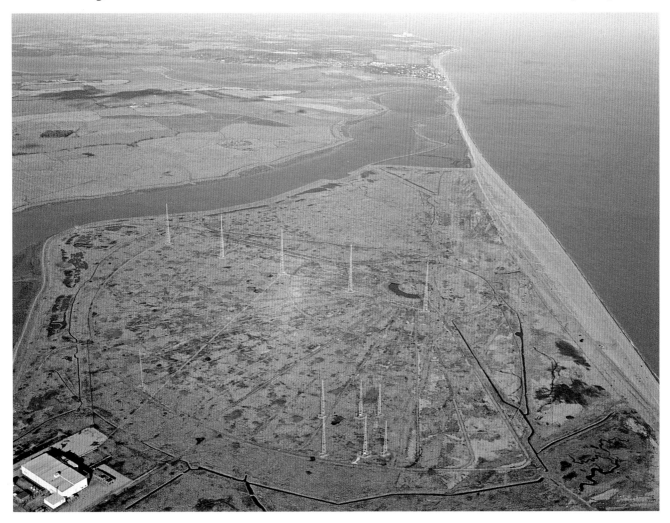

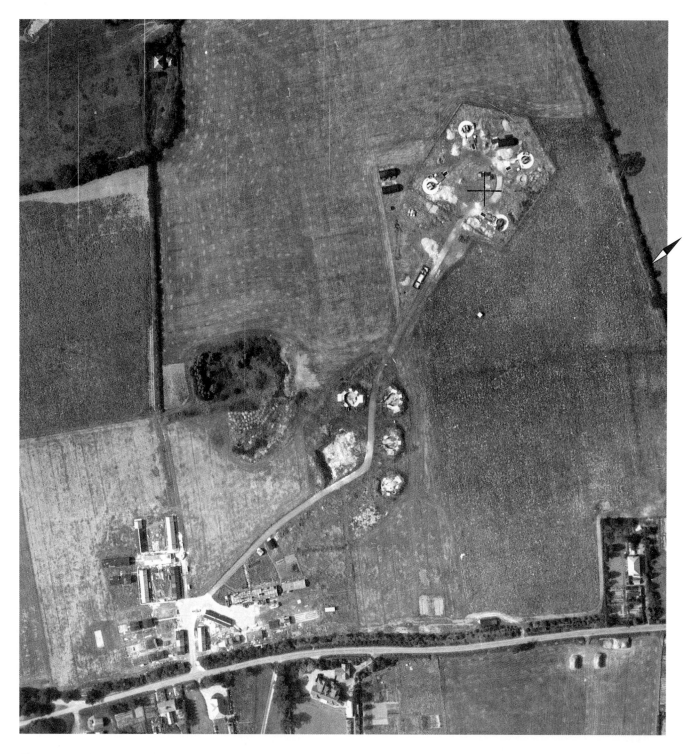

Fig 7.7 Heavy Anti-aircraft Artillery (HAA) batteries at Searson's Farm, Trimley St Mary, in 1948. A post-war battery, built in 1946 and visible 200m north-west of the partially demolished Second World War battery, indicates the development in gun-emplacement design during this period. (RAF 58/115 5006 30-AUG-1948 English Heritage (NMR) RAF Photography)

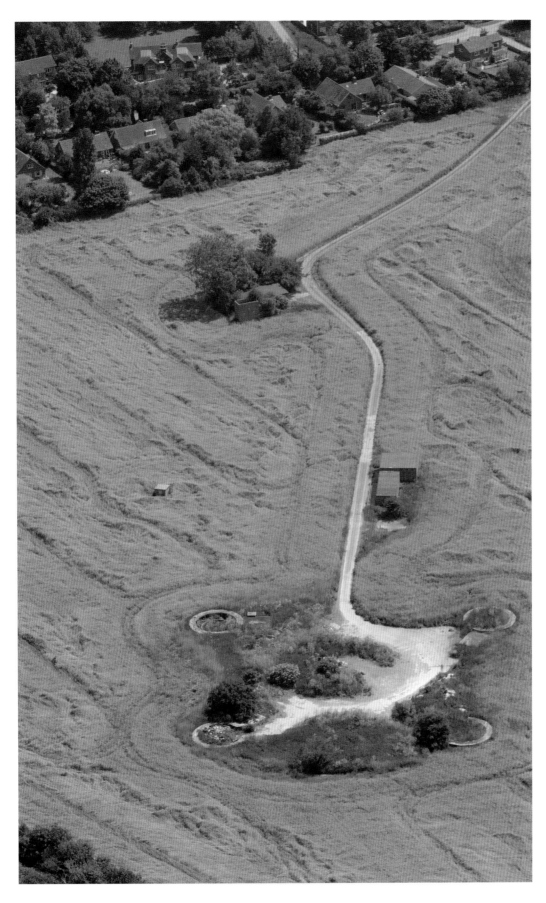

Fig 7.8 The Cold War (1946) HAA battery at Searson's Farm is well preserved. The gun pits are clearly visible, and a number of other structures also survive. (NMR 23963/12 27-JUN-2006 © English Heritage. NMR)

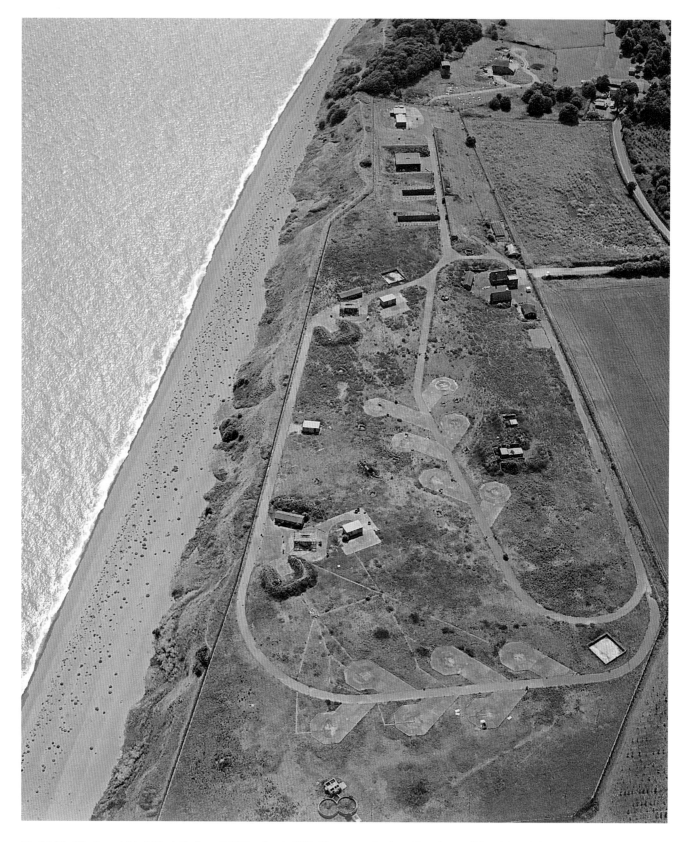

Fig 7.9 The Bloodhound Mark II missile site at RAF Bawdsey in 1998. The concrete hard standings for two flights of six missiles each, laid out in a herringbone pattern, are clearly visible. The site is in the northern part of the Bawdsey Radar Station, on the location of the Ground Control Interception radar (see Fig 7.4) (NMR 23916/7 27-JUN-2005 © English Heritage.NMR)

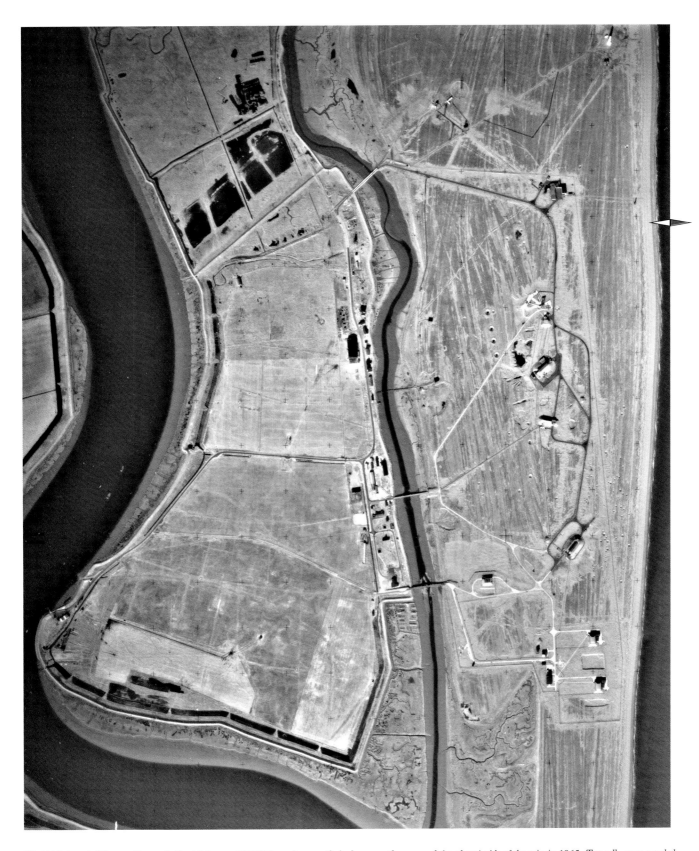

Fig 7.10 Atomic Weapons Research Establishment (AWRE) test base on Orfordness, on the seaward (southern) side of the spit, in 1965. Test cells, surr-ounded by banks of shingle and linked by a network of concrete roads, are clearly visible. To the north-west, across a narrow channel, are the remains of First and Second World War military establishments. (OS/65054 V108 30-APR-1965 © Crown copyright. All rights reserved. English Heritage 1000 19088. 2007)

Research and technological developments

Most Cold War military installations on the Suffolk coast were concerned with the early warning of, defence against or monitoring of a potential Soviet nuclear strike. By contrast the research facility at Orfordness was concerned with the development of the UK's own nuclear arsenal. The spit became the location for Cold War research into this new technology. From 1953 until 1971 the Atomic Weapons Research Establishment (AWRE) had a test site on the Ness (Fig 7.10).

Experiments were carried out on the ballistics of the nuclear bombs Britain was developing and on how various physical stresses, such as vibration, affected them. No nuclear material was actually present on the site. In order to carry out these experiments six large test cells were constructed, designed to absorb any explosions in the event of an accident. The massive concrete 'pagodas' show clear evidence of this in their design, with concrete roof supports designed to blow out easily, allowing the roof to drop and contain any accidental explosion (Fig 7.11).

The end of the Cold War

The fall of the Berlin Wall in 1989 heralded the end of the Cold War and precipitated the collapse of Communism in many Eastern European states as well as the disintegration of the Soviet Union. This momentous change in the global political situation led to the rapid decommissioning of hundreds of defence sites across the UK. Cold War military sites are now in the process of becoming part of the 'archaeological record' or 'historic environment', presenting a myriad of new and potentially complex management issues.

Fig 7.11 Two AWRE test cells, known as 'pagodas', on Orfordness in 2002. Their roofs are supported by relatively flimsy columns, designed to blow out so that the roof would seal any uncontrolled explosion. Shingle has been piled up around the structures, again to dampen the force of any accidental blast. (NMR 21914/23 07-NOV-2002 © English Heritage).

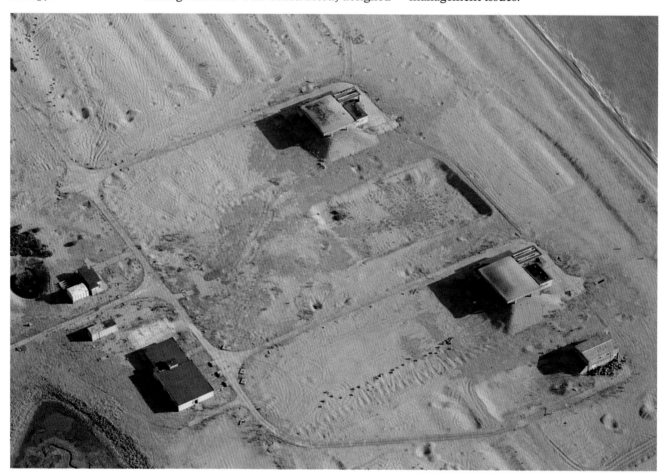

8

The future of Suffolk's coastal military remains

Previous chapters have demonstrated the importance of aerial photographs for studying military remains. Aerial photographs can be of even greater value when combined with other material, including the results of documentary research, archaeological surveys and excavation. The growing interest in modern military remains indicates the development of a more integrated approach to the study of our coastal legacy, rightly viewing them alongside sites of earlier periods.

This chapter will summarise the factors that have influenced the survival of coastal fortifications, and discusses how perceptions of modern military remains are changing in the face of new and continuing threats. It will also examine how aerial photographs can contribute to the assessment of fortifications' historic significance, and thus to the future protection of important sites.

Survival

Early fortifications

Military sites are now recognised as part of our heritage. Some have legal protection but for many, inclusion on the county Sites and Monuments Record (SMR) or Historic Environment Record (HER) may be more effective in ensuring their appreciation and survival.

On the Suffolk coast, fortifications such as Orford Castle and the surviving Martello Towers have had legal protection for many years through Scheduled Ancient Monument status. Such historic structures often survive well due to their substantial construction. They were built to last, even if the events that precipitated their construction passed relatively quickly. Orford Castle, for example, had ceased to be a Royal base by the early 14th century. The Napoleonic threat which the Martello Towers were built to face was fading even as the final tower, at laughden, was under construction.

Nonetheless many early fortifications have faced destruction and abandonment. Slaughden Martello Tower and Landguard Fort suffered periods of vandalism and neglect before their preservation was secured; only continuing strategic value ensured Landguard's survival until its decommissioning in 1957. Other defences, despite substantial construction, were not so fortunate. At Bawdsey, Martello Tower V's defensive role was very short-lived. Demolished in 1819 for its building materials, its footprint, now the site of a secret garden, gives an additional dimension to Bawdsey Manor's strategic importance. Tower N, at Felixstowe docks, survived only as a ruin until the early 20th century, and its surrounding battery was destroyed by port extension works in the 1980s.

Adaptation for alternative uses has ensured the survival of some fortifications, albeit often in a modified form. Slaughden Martello Tower's reuse as a residence and a coastguard station, and Orford Castle's varied roles from gaol to banqueting house, are cases in point. Orford's keep only avoided demolition because of its value as a navigation aid.

Suffolk's earlier coastal fortifications have thus survived fluctuations in fortune and fashion, in various states of completeness, to be recognised today as important historical monuments. Orford Castle was given protection under law ('scheduled') in 1913. In 1930 it was given to the Orford Town Trust, who in turn transferred it to guardianship of the Ministry of Works in 1962, the same year in which that ministry was redesignated the Ministry of Public Building and Works. It is now under the guardianship of English Heritage. Slaughden Martello Tower, scheduled in 1950, was rescued from dereliction by the Landmark Trust in the early 1970s, and is now in use as holiday accommodation. Landguard Fort's historical and architectural significance was recognised by scheduling in 1962, but it remained in dire need of renovation and restoration until the late 1990s. Now under the guardianship of

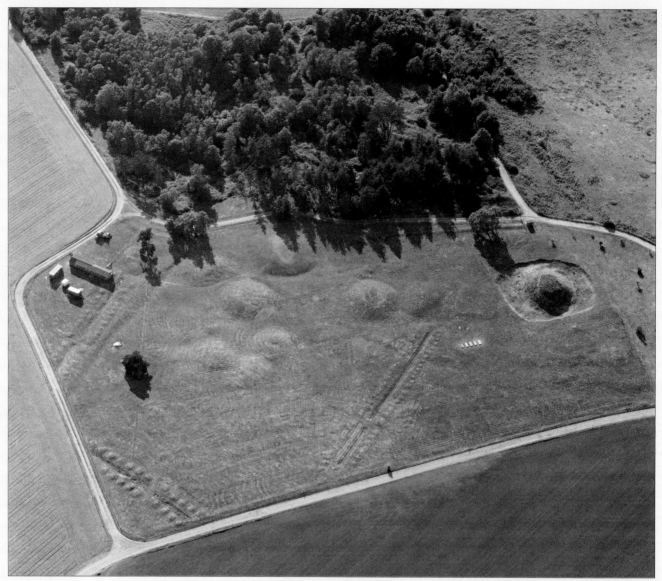

(NMR 15097/45 28-JUN-1994 © Crown Copyright.NMR)

Incidentally preserved remains

Second World War anti-glider ditches have been preserved as earthworks within the scheduled area of the Anglo-Saxon cemetery at Sutton Hoo (*above*). The remains of the medieval chapel at Leiston conceal a Second World War pillbox (*rght*).

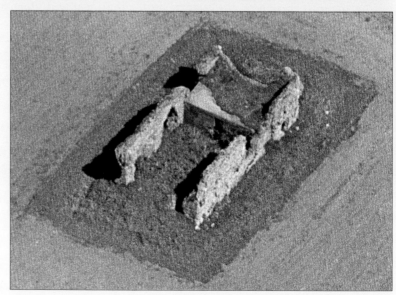

(NMR 23433/23 23-APR-2004 © English Heritage.NMR)

English Heritage, the fort is maintained and presented by volunteers from the Landguard Fort Trust.

Modern military remains

The survival of earlier fortifications contrasts with that of 20th-century anti-invasion defences and fortifications. Early 20th-century defences were often less substantial constructions than their historic predecessors, largely built 'for the duration' of the conflict or perceived threat, as with the rapidly evolving anti-invasion defences of 1939–45 (*see* Chapter 6). This has created problems for their survival, reuse and study.

In Suffolk the poor survival of modern military remains is the result of many factors, as discussed below. Most important were their ephemeral construction and post-war attitudes towards them. Post-war clearance of many military sites on public land was the responsibility of local authorities, and popular tourist towns and beaches such as Southwold and Aldeburgh were quickly cleared of obstructions. The morale-boosting potential of an accessible beach was not under-estimated, particularly after wartime restrictions. Local authorities undoubtedly had an eye on economic revival as well. Farmers were often paid to remove obstructions, thus restoring land to food production. But authorities and farmers alike occasionally baulked at the cost of demolishing larger emplacements in less accessible areas, and this reluctance was a factor in the survival of some of the isolated remains in which there is a growing interest today.

Until recently, modern coastal defences have been valued less highly than historical fortifications, and have rarely enjoyed legal protection. Exceptions include sites incidentally located within the scheduled areas of historic monuments (*see* opposite page). But the growing acknowledgement of the importance of 20th-century fortifications, manifest by their inclusion on county SMRs and HERs, for example, can be seen as the latest phase in a process of recognition and preservation.

Changing perceptions

Archaeological interest in modern military remains began in earnest with work carried out by amateur enthusiasts and volunteers, exemplified by Henry Wills' study of pillboxes (Wills 1985). The years since have seen increasing interest among heritage professionals, and more systematic studies building upon and incorporating earlier work. Recent surveys have contributed to a greater understanding of our military heritage amongst enthusiasts and professional archaeologists alike, but they can also contribute to a broader understanding of the monuments' place within the wider historic and natural environment. This is important, as understanding can lead to greater public appreciation, which in turn may lead to preservation and continued enjoyment.

There are, however, a number of potential obstacles to the popular appreciation of modern military remains. The Second World War, and to some extent the Cold War, are emotive subjects, and researchers in the past have encountered negative public attitudes: why preserve the reminders of a terrible conflict or indeed the threat of global annihilation, and delay time's healing effects?

Such attitudes are now less common, although more prosaic objections have been raised, based upon aesthetics or safety. Modern military remains are arguably uglier than older sites, and if neglected or abused they can also pose health and safety risks. Indeed, since the early post-war years surviving pillboxes, derelict gun batteries and other military structures have attracted activity seen by some as unpleasant or antisocial. A September 1951 letter to Ipswich Borough Council expresses a typical concern:

Dear Sir,

I would like to draw your attention to the condition of the pillbox between this road and Rushmere Road. I have noticed just lately that very unpleasant smells come out of this place and suggest that these are to the detriment of the young children of this neighbourhood who seem to enjoy playing around this unpleasant reminder of the past.

Although this pillbox is most probably the responsibility of the Ministry of Works or some like body, I consider that the Public Health Department should take steps to inspect this place and board up the entrance as soon as possible.

(IRP DC10/1/6/8)

It is true that military monuments remind some of us of difficult times, but strong arguments favour their preservation and greater understanding. Second World War monuments can have direct personal associations for veterans, their families and

Second World War sites as memorials

Military sites can provide a focus for remembering important historic events. This is exemplified by two memorials, one in Thetford Forest and one in the grounds of Orwell Park School, to the Desert Rats' time in East Anglia. The Thetford Forest memorial was founded by a veteran of the Division, Mr Les Dinning, and each year is the focus of a service of remembrance. Orwell Park School hosts an annual Desert Rats reunion and open day (*above*), also organised by a veteran, Mr Dennis Huett, where pupils can meet veterans and learn about their wartime experiences (*below, left*). These events recall the past whilst forging new links with the present and future. Sadly, both Mr Huett and Mr Dinning passed away during the writing of this book, but the memorials they founded will continue to honour their memory for many years to come (*below*).

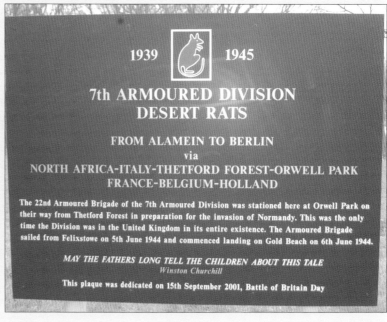

1939 1945

7th ARMOURED DIVISION
DESERT RATS

FROM ALAMEIN TO BERLIN
via
NORTH AFRICA-ITALY-THETFORD FOREST-ORWELL PARK
FRANCE-BELGIUM-HOLLAND

The 22nd Armoured Brigade of the 7th Armoured Division was stationed here at Orwell Park on their way from Thetford Forest in preparation for the invasion of Normandy. This was the only time the Division was in the United Kingdom in its entire existence. The Armoured Brigade sailed from Felixstowe on 5th June 1944 and commenced landing on Gold Beach on 6th June 1944.

MAY THE FATHERS LONG TELL THE CHILDREN ABOUT THIS TALE
Winston Churchill

This plaque was dedicated on 15th September 2001, Battle of Britain Day

(All photographs courtesy of Orwell Park School)

Recycled military remains

Suffolk's Second World War remains have already seen some reuse. In Aldeburgh a coastal battery gun house is now in use as a seafront shelter (*top*). The embarkation hard at Woolverstone Hall is now part of a modern marina complex (*middle*). In Felixstowe two communal air-raid shelters have been converted into office space (*bottom right*). More recently the Environment Agency reused many of the anti-tank cubes at Thorpeness as an economical and pragmatic reinforcement to existing sea defences south of the town (*bottom, left*).

(All photographs: Cain Hegarty)

local residents who remember them from their childhood, and can be a positive focus for commemoration, reunion or community projects. It is inevitable that as time passes personal associations will fade, but 20th-century military monuments can serve both as reminders and educational resources, particularly at significant times such as Second World War anniversaries (*see* p 92, for example).

Where safety is a genuine concern it is reasonable for military remains to be removed or made inaccessible. In the summer of 1954, 9 years after the war ended, a total of 43 children were injured by old defences in Suffolk, and the danger to bathers posed by the recent emergence of anti-tank cubes from the shingle near Thorpeness illustrates that safety is an ongoing concern. In some cases it may be possible to recycle military remains for beneficial reuse (*see* p 93), but where erosion is rendering coastal remains unsafe, isolation and consolidation may be the only options until nature takes its course.

The aesthetic qualities of a site are more subjective. A site seen as 'ugly' may simply reflect a lack of value for the viewer, and this perception may change once the site is better understood. A solitary pillbox may evoke the isolation of a soldier on a windswept stretch of defended shore, for example, or the anti-glider ditches at Sutton Hoo may add another layer of complexity to an already mysterious and beguiling archaeological landscape. The Atomic Weapons Research Establishment test cells or 'pagodas' on Orfordness have been likened to medieval castles, not only because they display the dominant technology and military might of their age, but also because their stark architecture is in dramatic contrast with the bleak natural landscape. Indeed the archaeology, history and natural surroundings of 'ugly' modern military sites have inspired a number of artists to reinterpret them by basing their work on, in or around them (*see* pp 96–7).

Threats

The growing interest in modern military fortifications has highlighted new and ongoing threats to Suffolk's coastal defences, both historic and modern.

Urban expansion, industry and agriculture

The expansion of post-war housing often obliterated the defences that once protected urban areas. Post-war industrial growth had a similar effect; the expansion of Felixstowe's vast container port, for example, has destroyed more of Landguard Point's military structures than any invasion in its history (Figs 8.1 and 8.2).

The greatest deliberate destruction of 20th-century military remains has been caused by post-war agriculture. To combat post-war food shortages as much land as possible was returned to cultivation and many anti-invasion measures such as antiglider ditches were quickly removed. By the 1950s government subsidies encouraged agriculture on previously uncultivated areas, accelerating this process. In Suffolk increasing areas of coastal heath and reclaimed salt marsh – previously uncultivated land well suited to military installations – were turned over to the plough. This completely eliminated many of the more insubstantial military sites such as earthworks and light anti-aircraft emplacements. Only the most immovable parts of some previously substantial installations now survive, as illustrated by the isolated HAA batteries at Searson's Farm (*see* Fig 7.8) and at Lound, and AFV range blockhouses on Boyton marsh (Figs 8.3 and 8.4).

Erosion

Today the sea is the ultimate threat to Suffolk's surviving military fortifications. Of course coastal erosion is not a recent threat: Walton Castle, the Roman fort at Felixstowe, was lost to the sea in the 18th century and Slaughden Martello Tower long ago lost its associated beach battery. This process is ongoing and indiscriminate, affecting both military and non-military remains. Slaughden Martello Tower lost part of its curtain wall to the sea in the 1970s, and the medieval monastic site of Dunwich Greyfriars – the last surviving remnant of the once large and prosperous fishing port of Dunwich – will almost certainly be lost within 50 years. In places not only have Second World War defences been lost but the entire coastline upon which they were built is gone. Elsewhere fortifications await inevitable destruction atop crumbling cliffs.

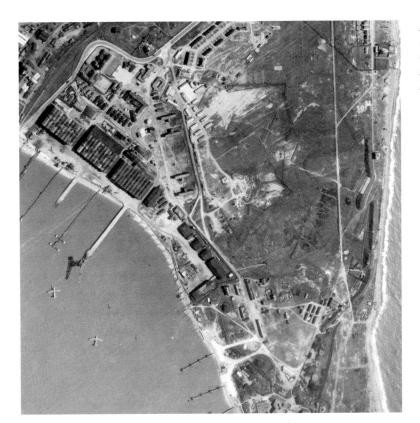

*Fig 8.1 Felixstowe, 1946.
(RAF 106G/UK/1492/RS
4081 10-MAY-1946
English Heritage (NMR)
RAF Photography)*

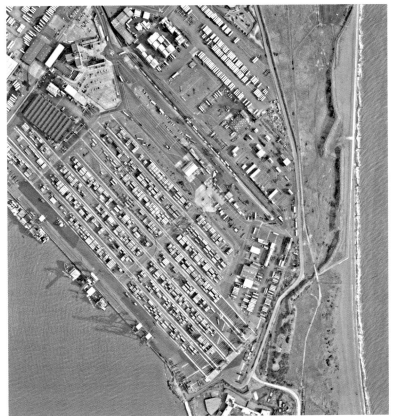

*Fig 8.2 Felixstowe, 1989.
Expansion of the container
port since the Second World
War has almost completely
destroyed military remains
from the two World Wars
once visible north of
Landguard Fort.
(OS/89044 V066
18-MAR-1989 © Crown
copyright. All rights
reserved. English Heritage
100019088.2007)*

Art and military remains

For artist Louise K Wilson, the changing balance between artificial and natural spaces was central to her temporary installation at Orfordness. Site management at the Ness (now owned by the National Trust) has struck a pragmatic balance between environmental conservation and archaeological preservation. In the autumn of 2005 Wilson's work reflected this process of change from state-of-the-art science site to nature reserve, from inaccessible high security to crumbling archaeology, by projecting sounds of Cold War equipment into the now-empty laboratories. The hum of machines and technician's voices mingled with the songs of nesting birds, and a choir performed a specially commissioned piece of music, recorded at the site (*below*).

(Photograph: Louise K Wilson)

94

Suffolk's Second World War coastal defences inspired Bettina Furnée to create five temporary, site-specific installations with the overall title of 'If Ever You're in the Area'. Text-based installations displayed from May to December 2005 in and around the remains of the East Lane (Bawdsey) coastal battery combined the dominant themes of the site – the fear of invasion and the local experience of living on the front line of war – with the bleak beauty of the coastline (*above*). They reflected the fortification's relationship with the sea, as coastal erosion slowly destroys the defences that war did not.

(Photograph: Douglas Atfield)

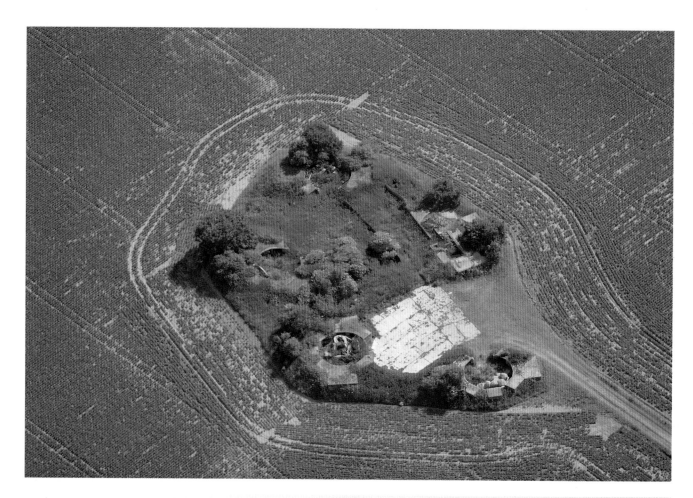

Fig 8.3 The isolated remains of the HAA battery at Lound. (NMR 23967/027 27-JUN-2005 © English Heritage.NMR)

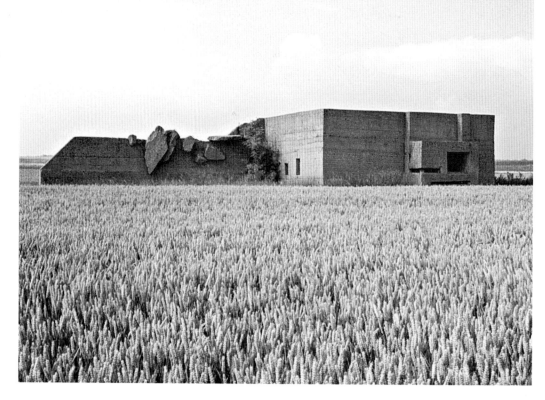

Fig 8.4 One of the remaining AFV range blockhouses at Boyton (Photograph: Adrian James)

Eroding remains

Military remains, both historic and modern, have felt the dramatic effects of erosion on Suffolk's coast, demonstrated here by the partial destruction of a searchlight at East Lane, Bawdsey (*left*), and of a pillbox north of Thorpeness (*below*). In some areas the loss of the Second World War landscape has been total.

(Photograph: Helen Winton)

(NMR 23967/027 27-JUN-2006 © English Heritage.NMR)

Assessment of the resource

The loss of Suffolk's coastal fortifications is thus part of a complex process involving demolition, post-war development and natural processes, either understandable or unavoidable. By the 1990s, however, archaeologists recognised that the number of modern defences surviving in good condition was dwindling. This was exacerbated by the sale for redevelopment, by the Ministry of Defence (MoD) of newly redundant Cold War establishments which were receiving growing interest but were little understood outside of secret MoD files. The time had come for the distribution, survival and condition of our modern military heritage to be thoroughly assessed.

By the 1990s English Heritage, recognising the seriousness of the problem, had expanded its national assessment of the condition of archaeological resources, the Monuments Protection Programme (MPP), to include modern military remains. This aspect of the MPP ran alongside the Council for British Archaeology's Defence of Britain (DoB) project, which built upon popular interest in the subject by using the enthusiasm and knowledge of hundreds of volunteers to systematically record the survival of defences in the field for the first time.

The DoB project was predicated on the belief that little documentation existed. This misapprehension was corrected in the mid-1990s when the MPP commissioned a detailed documentary survey of 20th-century remains. The MPP's Twentieth Century Fortifications of England project identified a vast documentary resource for 20th-century defences. This went a long way towards identifying the original population, distribution, appearance and survival of many classes of fortification, allowing the DoB project to focus on anti-invasion defences, a class of site too large for the archive survey to easily assess.

Survival alone may not be a sufficient reason to preserve modern military remains. By describing the typicality, rarity and condition of military monuments or their survival in an important group, these surveys have created a valuable resource for researchers and archaeologists working within local and national government. This data will allow a thorough assessment of surviving remains, and encourage well-informed recommendations to the government as to which are of national importance and may warrant protection through scheduling or listing, and which could be best served by local management such as inclusion on an SMR or other local list, often the most effective protection available.

The use of aerial photographs in assessment

Recent aerial photographs have been used as a second stage in the MPP's assessment process, for rapidly assessing sites identified from the documentary survey. The documents provide good site-location information, while assessment of the photographs has proved effective in identifying the survival and status of many wartime installations. Together these provided information sufficient to determine potential national importance, at which point archaeologists visited the actual sites to confirm their location and survival and to meet with their owners.

In a national project conducted at speed, there will inevitably be inaccuracies. The more detailed National Mapping Programme (NMP) survey of all available photographs, including wartime images, has confirmed that reliance on documentary evidence alone can result in some misinterpretations, as wartime reality may differ from documented strategies. For example, in the Orford area the NMP survey has found Operation Diver batteries up to 300m from their documented locations, and has even recorded batteries not identified by the archive survey (Fig 8.5). Searching for remains only in areas identified from archive sources could therefore potentially lead to misidentifications and omissions.

In Suffolk the NMP survey has also proved particularly valuable in understanding surviving anti-invasion beach defences. Their incomplete and isolated remains are unrepresentative of their original distribution and the Suffolk NMP project has now placed these fragmentary remains into a wider landscape context, reconnecting them with the better understood fortifications. Other NMP projects are doing the same for other defended coastlines including Essex, Norfolk and Cornwall.

The NMP data can therefore enhance information already available from other sources for assessing the significance of surviving remains. For example, the recently completed Defence Areas Project, part of English Heritage's characterisation programme, aims to promote the greater enjoyment, understanding and informed management of Second World War defence landscapes. The project built upon the DoB

assessment of individual remains to identify coherent groups of 20th-century anti-invasion defences that survive as representative examples within largely unchanged landscape settings. In Suffolk, Bawdsey Point and Walberswick were identified as areas with such significant remains. The NMP project has provided important information about the original wartime context, in support of the recommendation to protect these valuable survivors of Suffolk's wartime landscape.

The future

What does the future hold for Suffolk's modern military remains? The growing interest in recent fortifications coincides with a move towards seeing historic remains as part of the wider historic landscape. Historic coastal sites and landscapes are in turn increasingly being recognised as important parts of the modern coastal character. The pressure upon this complex environment, composed as it is of historic, natural and economic elements, is clearly illustrated at Landguard Point, where Britain's largest container port sits alongside the historic fort and a nationally important wildlife reserve. The management of coastal historic remains must therefore also be considered alongside issues of economic development and environmental sustainability.

Coastal groups, comprised of bodies such as the Environment Agency and local authorities, are developing Shoreline Management Plans to assess the long-term impact of a changing coastline on all aspects of the coast, from settlements, industry and farmland to wildlife habitats and historic remains. However, it is currently unlikely that even the presence of scheduled archaeological sites will cause an area to be protected against coastal erosion. A shift in terminology from 'Coastal Defence' to 'Coast and Flood Risk Management' reflects a more realistic approach, accepting that total defence against coastal erosion is not, and never was, a realistic possibility.

The impact of agriculture on the landscape has also been recognised. The Department for Food and Rural Affairs has launched Environmental Stewardship Schemes, intended to encourage farmers to manage historic remains and environmentally important areas in a complementary and sensitive manner.

Of the greatest significance, however, is that information distilled by the National

Mapping Programme from thousands of aerial photographs now enhances both Suffolk's SMR in Bury St Edmunds and English Heritage's National Monuments Record in Swindon. The county's NMP results are publicly available to a new generation of researchers and amateur and professional archaeologists.

As popular involvement in our military coastal heritage grows, expressed through media such as the artistic installations at Orfordness and East Lane and pillbox-themed coastal walks proposed by the Defence Areas Project, it is hoped that books like this will demonstrate the value of aerial photographs and the National Mapping Programme in helping us understand the military remains, and the wider historic environment, around us.

This knowledge will increase appreciation of the surviving remains and the conservation issues that determine their future, whilst complementing the educational role of established memorials and events such as those at Orwell Park School. Increased public appreciation can help to ensure that Suffolk's most representative and best preserved remains win their final battle – against neglect and destruction – so that future generations may appreciate them alongside the castles and forts that make up their historic coastal military heritage.

Fig 8.5 Diver batteries in the Orford area (© Crown copyright. All rights reserved. English Heritage 100019088. 2007)

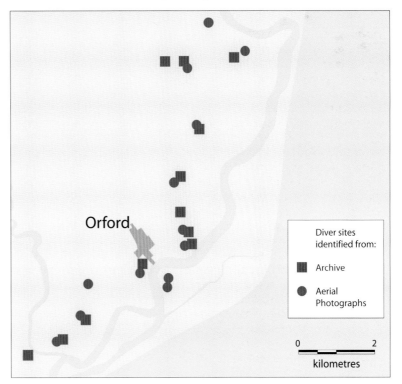

Bibliography

Anderton, M J 1998 *Twentieth Century Military Recording Project: World War Two Operation Diver Batteries*. Swindon: Royal Commission on the Historical Monuments of England

Barker, L 2004 *Orford Castle, Orford, Suffolk* (Archaeological Investigation Report Series AI/22/2004). Swindon: English Heritage

Bewley, R 2001 'Understanding England's historic landscapes: an aerial perspective' *Landscapes* **2** (1), 74–84

Bowden, M 2001 'Mapping the past: O G S Crawford and the development of landscape studies'. *Landscapes* **2** (1), 29–45

Cocroft, W D 2001 *Cold War Monuments: An Assessment by the Monuments Protection Programme*. London: English Heritage

Cocroft, W D and Thomas, Roger J C 2003 *Cold War: Building for Nuclear Confrontation 1946–1989*. Swindon: English Heritage

Commissioners Appointed to Consider the Defences of the United Kingdom 1860 *Report of the Commissioners Appointed to Consider the Defences of the United Kingdom*. London: HMSO

Crawford, O G S and Keiller, A 1928 *Wessex from the Air*. Oxford: Clarendon Press

Cruickshank, D 2001 *Invasion: Defending Britain from Attack*. London: Boxtree

Daniel, G E 1950 *A Hundred Years of Archaeology*. London: Duckworth

Department for Environment, Food and Rural Affairs 2006 *Shoreline Management Plan Guidance* (2 vols). www.defra.gov.uk /environ/fcd/policy/smpg

Deuel, L 1971 *Flights into Yesterday*. London: Macdonald

Dewing, G 1998 *Air Station Aldeburgh: 1915–1919*. Privately published

Dobinson, C 1996 *Anti-invasion Defences of World War II* (Twentieth Century Fortifications in England 2). York: Council for British Archaeology

Dobinson, C 1996 *Operation Diver: England's Defence against the Flying Bomb, June 1944–March 1945* (Twentieth Century Fortifications in England 4). York: Council for British Archaeology

Dobinson, C 2000 *Acoustics and Radar: England's Early Warning Systems 1915–45* (Twentieth Century Fortifications in England 7). York: Council for British Archaeology

Dobinson, C 2000 *Civil Defence in World War II: Protecting England's Civil Population 1935–45* (Twentieth Century Fortifications in England 8). York: Council for British Archaeology

Dobinson, C 2000 *Coast Artillery, 1900–56* (Twentieth Century Fortifications in England 6). York: Council for British Archaeology

Dobinson, C 2000 *The Cold War: Aspects of England's Defences in the Early Nuclear Age, 1947–69* (Twentieth Century Fortifications in England 11). York: Council for British Archaeology

Dobinson, C 2000 *Fields of Deception: Britain's Bombing Decoys of World War II*. London: Methuen

Dobinson, C 2000 *Operation Overlord: Embarkation Works for the Invasion of Occupied Europe 1942–44* (Twentieth Century Fortifications in England 5). York: Council for British Archaeology

Dobinson, C 2001 *AA Command: Britain's Anti-Aircraft Defences of World War II*. London: Methuen

Dobinson, C (forthcoming) *Building Radar: Forging Britain's Early-Warning Chain, 1939–45*. London: Methuen

Dymond, D and Martin, E (eds) 1999 *An Historical Atlas of Suffolk*. Ipswich: Suffolk County Council & Suffolk Institute of Archaeology and History

English Heritage 1998 *Monuments of War: The Evaluation, Recording and Management of Twentieth-Century Military Sites*. London: English Heritage

English Heritage 2003 *The Archaeology of Conflict. Conservation Bulletin* 44

English Heritage 2003 *Coastal Defence and the Historic Environment: English Heritage Guidance.* Swindon: English Heritage

English Heritage 2003 *Twentieth-Century Military Sites.* London: English Heritage

English Heritage 2005 *Maritime and Coastal Heritage. Conservation Bulletin* 48

English Heritage and the Royal Commission on the Historical Monuments of England 1996 *England's Coastal Heritage: A Statement on the Management of Coastal Archaeology. London:* English Heritage

Fairclough, J and Plunkett, S J 2000 'Drawings of Walton Castle and other monuments'. *Proceedings of the Suffolk Institute of Archaeology and Natural History* **39**, 419

Foot, W 2006 *Beaches, fields, streets, and hills: the anti-invasion landscapes of England, 1940* (CBA Research Report 144). York: Council for British Archaeology

Foot, W and Thomson, C 2004 *Defence Areas: A National Study of Second World War Anti-Invasion Landscapes in England.* English Heritage and Council for British Archaeology

Furnée, B, *If Ever You're in the Area.* www.ifever.org.uk

Gale, A 2000 *Britain's Historic Coast.* Stroud: Tempus

Gurney, D 2002 *Outposts of the Roman Empire: A Guide to Norfolk's Roman Forts at Burgh Castle, Caister-on-Sea and Brancaster.* Norwich: Norfolk Archaeological Trust

Hadwen, P, Smith, J, White, P and Wylie, N 2001 *Felixstowe at War: A Military History.* Felixstowe: Neil Wylie

Hegarty, C and Newsome, S 2005 'The Archaeology of the Suffolk Coast and Inter-Tidal Zone: A Report for the National Mapping Programme'. Unpublished report, National Monuments Record Centre

Heslop, T A 1991 'Orford Castle, nostalgia and sophisticated living'. *Architectural Review* **34**, 36–58

Higgins, D S (ed) 1980 *The Private Diaries of Sir H Rider Haggard.* London: Cassell

Kent, P 1988 *Fortifications of East Anglia.* Lavenham: Dalton

Kent, P 1989 'East Anglian fortifications in the twentieth century'. *Fortress* **3**, 4–57

Kinsey, G 1978 *Seaplanes Felixstowe: The Story of the Air Station 1913–1963.* Lavenham: Dalton

Kinsey, G 1981 *Orfordness Secret Site: A History of the Establishment 1915–1980.* Lavenham: Dalton

Kinsey, G 1983 *Bawdsey Birth of the Beam: The History of RAF Stations Bawdsey and Woodbridge.* Lavenham: Dalton

Lowry, B (ed) 1995 *20th Century Defences in Britain: An Introductory Guide.* York: Council for British Archaeology

Lowry, B 2004 *British Home Defences, 1940–45.* Oxford: Osprey

MacArthur, B (ed) 1999 *The Penguin Book of Twentieth-Century Speeches.* Penguin Books

MacDonald, A S 1992 'Air photography at Ordnance Survey from 1919 to 1991'. *Photogrammetric Record* **14** (80), 249–60

Moore, I E, Plouviez, J and West, S 1988 *The Archaeology of Roman Suffolk.* Ipswich: Suffolk County Council

Nesbitt, R C 1996 *Eyes of the RAF: A History of Photo-Reconnaissance,* 2 edn. Godalming: Bramley Books

Pattison, P *The Defences of Orwell Haven: An Outline History* (draft). Swindon: English Heritage

Pearson, A 2002 *The Roman Shore Forts.* Stroud: Tempus

Pile, F A, Sir 1949 *Ack Ack. Britain's Defence Against Air Attack During the Second World War.* London: Harrap

Rhodes, J 2003 *Orford Castle.* London: English Heritage

Riley, D N 1987 *Air Photography and Archaeology.* London: Duckworth

St Joseph, J K 1951 'A survey of pioneering in air-photography past and future', *in* Grimes, W F (ed) *Aspects of Archaeology in Britain and Beyond.* London: H W Edwards 303–15

Saunders, A D 1989 *Fortress Britain: Artillery Fortifications in the British Isles and Ireland.* Liphook: Beaufort

Saunders, A D 1997 *Channel Defences.* London: Batsford

Schofield, A J 2000 'Now we know: the role of research in archaeological conservation practices in England' *in* McManamon, F P and Hatton, A *Cultural Resource Management in Contemporary Society* (One World Archaeology 33). London: Routledge

Schofield, J 2000 *MPP 2000: A Review of the Monuments Protection Programme, 1986–2000.* London: English Heritage

Schofield, J 2002 'Monuments and the memories of war: motivations for preserving military sites in England' *in* Schofield, J, Johnson, W G and Beck, C M (eds), *Materiél Culture: The Archaeology of Twentieth-Century Conflict* (One World Archaeology 44). London: Routledge

Schofield, J 2002 'The role of aerial photographs in national strategic programmes: assessing recent military sites in England' in Bewley, R H and Rączkowski, W (eds) *Aerial Archaeology: Developing Future Practice* (NATO Science Series 1:337). Amsterdam: IOS Press

Schofield, J 2004 *Modern Military Matters. Studying and Managing the Twentieth-Century Defence Heritage in Britain: A Discussion Document*. York: Council for British Archaeology

Sutcliffe, S 1972 *Martello Towers*. Newton Abbot: David and Charles

Telling, R M 1997 *English Martello Towers: A Concise Guide*. Beckenham: CST Books

Trollope, C 1983 'The Defences of Harwich'. *Fort* **11**, 5

Turner, F R 1994 *The Maunsell Sea Forts, Part One: The World War Two Naval Sea Forts of the Thames Estuary*. Privately published

Wainwright, A 1996 'Orford Ness' *in* Morgan Evans, D, Salway, P and Thackray, D *The Remains of Distant Times: Archaeology and the National Trust* (Society of Antiquaries of London occasional paper 19). Woodbridge: Boydell Press

Watkis, N C 1999 *The Western Front from the Air*. Stroud: Sutton

Wills, H 1985 *Pillboxes: A Study of UK Defences 1940*. Leo Cooper in association with Secker and Warburg

Wilson, D R 2000 *Air Photo Interpretation for Archaeologists*, 2 edn. Stroud: Tempus

Wilson, L K, *A Record of Fear*: www.commissionseast.org.uk/ NT_ EH/new_record_of_fear.html

Zimmerman, D 2001 *Britain's Shield: Radar and the Defeat of the Luftwaffe*. Stroud: Sutton

Web sources

The Battle of Britain History Site: www.raf.mod.uk/bob1940/bobhome.html

Bawdsey Radar Group: www.bawdseyradargroup.co.uk

BBC History: www.bbc.co.uk/history

The Defence of Britain Project: www.britarch.ac.uk/projects/dob

English Heritage, Aerial Survey: www.english-heritage.org.uk

Imperial War Museum: www.iwm.org.uk

Landguard Fort Trust: www.landguard.com

Landmark Trust: www.landmarktrust.org.uk

Orford Ness National Nature Reserve (National Trust): www.nationaltrust.org.uk/orfordness

Subterranea Britannica: www.subbrit.org.uk

Suffolk Coast and Heaths: www.suffolkcoastandheaths.org

Tank Museum: www.tankmuseum.org.uk

Suffolk County Council Archaeological Service: www.suffolk.gov.uk/Environment/ Archaeology

Desert Rats Memorial Trust: www.desertrats.memorialassoc.btinternet. co.uk

Sources and Archives

The Aerial Reconnaissance Archives
Keele Information Services
Keele University
Staffordshire ST5 5BG

Tel: 01782 483061
Fax: 01782 583335
Email: evidenceincamera@keele.ac.uk
Website: www.evidenceincamera.co.uk

Air Photo Library – CUCAP
Unit for Landscape Modelling
University of Cambridge
Sir William Hardy Building
Tennis Court Road
Cambridge CB2 1QB

Tel: 01223 764377
Fax: 01223 764381
Email: library@uflm.cam.ac.uk
Online catalogue:
http://venus.uflm.cam.ac.uk/

Photograph Archive
Imperial War Museum
Lambeth Road
London SE1 6HZ

Tel: 020 7416 5333 / 5338 / 5309
Fax: 020 7416 5355
Email: photos@iwm.org.uk
Webpage: http://collections.iwm.org.uk

The National Archives
Kew, Richmond
Surrey TW9 4DU

Tel: 020 8876 3444
Website: www.nationalarchives.gov.uk

National Monuments Record
English Heritage
Kemble Drive
Swindon SN2 2GZ

Tel: 01793 414600
Fax: 01793 414606
Email: nmrinfo@english-heritage.org.uk
Website: www.english-heritage.org.uk

The National Trust
East of England
Westley Bottom
Bury St Edmunds
Suffolk IP33 3WD

Tel: 01284 747500
Fax: 01284 747506
Website: www.nationaltrust.org.uk

Suffolk Record Office
Gatacre Road
Ipswich
Suffolk IP1 2LQ

Tel: 01473 584541 (Searchroom)
Tel: 01473 584533 (Public Service
Manager)
Fax: 01473 584533
Email: ipswich.ro@libher.suffolkcc.gov.uk
Website: www.suffolk.gov.uk/LeisureAnd
Culture/LocalHistoryAndHeritage/
SuffolkRecordOffice/

Suffolk Sites and Monuments Record
Suffolk County Council Archaeological
Service
Shire Hall
Bury St Edmunds
Suffolk IP33 2AR

Tel: 01284 352445
Fax: 01284 352443
Email: archaeology@et.suffolkcc.gov.uk
Website: www.suffolk.gov.uk/Environment/
Archaeology/SitesAndMonumentsRecord/

The Tank Museum
Bovington
Dorset BH20 6JG

Tel: 01929 405096
Email: admin@tankmuseum.co.uk
Website: www.tankmuseum.co.uk

Index

Illustrations are denoted by page numbers in **bold**

A

A&AEE (Aeroplane and Armament Experimental Establishment) 32
aerial archaeology, origins 4
aerial photography
 First World War 4, **4**, 27
 oblique 7, 8–9, 27, **31**
 origins 4–5
 overlaps 8
 post-war 8–10
 RAF 7–8, **8**
 Second World War 5, 35
 sources 10
 surveys 3
 use 3
 use in site assessment 98–9
 value 3, 87
 vertical 7, **7**, **8**
Aerial Reconnaissance Archives, The (TARA) 5
Aeroplane and Armament Experimental Establishment (A&AEE) 32
agricultural expansion 92, 99
Air Raid Precautions Department 43
air raid shelters
 Anderson 43, 52
 communal 50, **51**, 52
 industrial 52
 Morrison 52
 public 50, **50**
 reuse 91, **91**
 trench 43, 48, **48**, **49**, 50, **50**
air raids
 First World War 25, 27
 Fringe Target Raids 39, 50, 52
 Second World War 39, 42, 52, 72–3
Air Warfare Analysis 43
Aldeburgh
 aerodrome commissioned 27
 air raid (1942) 39
 coastal battery 92, **92**
 defences, 16th century 15

linear beach defences 57, **57**
Martello Towers 21
ROC post 78
Aldeburgh Emergency Battery 53, **53**, 54, **54**, **55**
Allen, WGW 5, **6**
American War of Independence (1775–83) 15, 17
Anderson, Sir John 43
anti-aircraft artillery
 Cold War 81, **82–3**
 Diver batteries 60, **62**, 74–5, **74**, **75**, 99
 First World War 27
 Heavy Anti-aircraft batteries 36, **37**, **38**, 39, 81, **82–3**, 92, **96**
 Second World War deployment 35
Anti-Aircraft Command 39
anti-invasion defences
 anti-glider ditches 58, **58**, 88, **88**, 92
 anti-tank ditches 57, **57**
 anti-tank islands 63
 anti-tank scaffolding **56**
 barbed wire 60, **61**
 Felixstowe 25, **25**
 First World War 24–5, 28
 First World War pillboxes 25, **25**, 26, **26**
 linear beach defences 57, **57**, 58
 obstructions 58
 Second World War **2**, 52–4, **53**, **54**, **55**, **56**, 56–60, 57, **58**, **60**, **61**, **62**
 Second World War pillboxes 56, 59, **59**, 60, 63
 stop-lines 56
 survival 88, **88**, 89, 91, **91**, 92
Anti-Submarine Observers' School 29
anti-tank defences **56**, 57, **57**, 58, 60, 63, 91, 92, **92**
Armament Experimental Flying Section 27
armaments tests 32, **32**, 71, **72–3**
arms race 79
Army formations
 7th Armoured Division (the Desert Rats) 66, 70, 90, **90**

79th Armoured Division 72
 Royal Armoured Corps 66
art and artists **94**, 94–5, **95**, 99
Atlantic Wall, the 72
Atomic Weapons Research Establishment, Orfordness 2, **85**, **86**, 86, 92, **94**, 94
aviation technology 4, 5

B

Ballistics Building, Orfordness 32, **32**
barrage balloons 42, **42**, **44**, 45, **45**
Battle of Britain 41, 52
Bawdsey
 coastal battery 95, **95**
 Martello Tower **19**, 87
 pillboxes 26
 searchlights 97, **97**
Bawdsey Manor 33, 87
Bawdsey Point 99
Bawdsey Radar Station 33, **34**, 39, 41, 77–8, **79**
Bloodhound installation 81, **84**
beach clearances 91
Bentwaters 77
Bigod, Hugh 14
Blitz, the 39, 52
Bloodhound surface-to-air missiles 81, **84**
Bonaparte, Napoleon 18, 19
Boyton AFV range 66, 68, **68**, 92, **96**
Brackenbury battery **24**
Brooke, General Alan Francis 52, 56, 59, 63
Bucklesham decoy 46, **47**
Burgh Castle, Norfolk 12, **12**
Butley **31**

C

Cambridge University Collection of Aerial Photographs 10
cameras 4, 5
camouflage 53
castles 13–14, 87
Central Flying School 27